Custody of the Eyes

MONTANA

Custody of the Eyes
Diamela Eltit

Translated by Helen Lane & Ronald Christ

Sternberg Press

For my children,
Nadine and Felipe

My thanks in the Mexican period of this book
to the writer Margo Glantz
and the young man Guido Camù

No, I do not fear
the pyre that
will consume me
but the badly lit
match and this
vial that gets in
the way of the
hand I write with.

Rosario
Castellanos

baaam

Mama writes. Mama is the only one who writes.

Mama and I share the whole house in every sense. The house is noisy, sometimes calm. Calm. Mama is not calm, I see it in her pimply calf. Many little patches of her skin are disorderly. Disorderly. What fingers I have are angered by the disorderliness. When I am angered my heart TOM-TOM TOM-TOM and I can't hold it back because it seems to say DUM-DUM DUM-MY. I'll be the dummy in every corner of the house. The unbelievable tininess of the house is uppermost in my mind. In my mind I foresee gloomy days, sleepy landscapes. I foresee nothing but the horror. My body speaks, my mouth's asleep. My mind contains the dumb house in startling tininess. I move among the multitude of my clay vessels, bearing the weight of a deep sexual need. Precocious. Precocious. It hurts me. I grab hold of the vessel. Of the vessel. Like a larva I'll climb up the vessel. But the vessel changes into a calf. It's muscular. Muscular. Not me. My slack body speaks, my tongue has no musculature. Is dumb. I'll climb upward, clinging tightly to the vessel, dumb slobberer that I am I'll climb upward. My tongue is so difficult it doesn't stop the drool from dripping and my drool stains the vessel that now has changed into a calf and maybe that's how I'll snag a little musculature. My heart thumps like a tom-tom. TOM-TOM TOM-TOM. It's muscular. My heart speaks to me all the time about its precocious sexual resentment. Tells me about it in

a difficult tongue (just now/ I saw one of those bits I dream of/ in pieces/ I dream of in pieces/ it hurts hurts hurts/ here/ right here/ very warm/ a little more/ a little more/ crap/ I have lots left over/ a very warm space/ the molar that bites/ devours/ right now/ the fat/ how dark/ how horrible/ does the forest of my desires really exist?/). I don't want to know about it. I know about everything. The calf tries to demolish me with its teeth so as to leave me abandoned in a corner of the house. I know it. I know it. Mama bends toward me and her mouth appears sardonic. Sardonic. She bends and I suspect she wants to peel me off with her teeth. Slobbering I let out a deafening laugh. Oh my, how I laugh. How I laugh. I fall to the floor and drag myself along the floor. It's nice, solid, sweet. I bang my head of a dum-dum, ᴡᴀᴋ ᴡᴀᴋ ᴡᴀᴋ ᴡᴀᴋ it sounds hard, my head of a dum-dum, of a dum-dum. ᴅᴜᴍ-ᴅᴜᴍ ᴅᴜᴍ-ᴍᴜ. She picks me up off the floor. Mama's furious, the calf, my vessel. I hook in good and drool runs all over. How long have we been at this? A day? A minute? I don't know. Oh, if I could only talk. Just think if at last I talked (in the end it'll end, it'll end, go, go, go, it'll end). Mama's right, no charity at all, and how nice to have banged my head and, oh yes, laughed. I have an infinite reserve of drool. All day drool all the time. Me and my vessel always wet. First I wet it, then I dry it. When he writes to Mama my heart steals his words. He writes her crap. Crap. (Now/ hurry up/ You want it harder?/ Harder?/ HURRY UP/ More where?/ why don't

you hurry up/ enough/ don't cry/ don't bother me/ it's started/ it's started/ don't pull that face/ why do you have to pull that face?/) He doesn't write these words to her, he only thinks these words. I read her the words he thinks and doesn't write her. My heart retains his words. His words. My heart learns crap and I'm so fond of my head of a dummy. DUM-DUM DUM-MY. I grab hold of one of my vessels and I see a calf into which I can sink what few nails I have. I couldn't bloody a vessel, only a calf. *SCRRR*, I scrape my leg looking around the house. I stop and I stoop for Mama. Mama hits me in my head of a dum-dum. *AAAE*, it hurts. It hurts. Another vessel and another. Mama puts me on the floor and I stain the floor with my drool. I go outside to stain the ground with my drool. My drool changes the color of the ground. I don't know what color it turns. I dig a little hole in the ground with my finger. Mama takes my finger out of the hole and twists my hand. My hand. If she continues, *baaam, baaam*, I'll laugh. I dig another little hole and then put my fingers in my dumb mouth. Dumb mouth. My drool thickens now and I drag myself to the ground, my mouth hanging open. Open. Mama looks at me and I get horny and I *SCRRR* myself, scraping my eye bloody. I put my finger in my eye. Mama grabs hold of my finger and puts it in my nose. My nose. Don't want that. I want one of my vessels. I go looking for my vessel and put my fingers inside. Inside. Mama gets mad, and I laugh. She can't stand my laughing, and that's why I do it. If I laugh

her heart sounds like a tom-tom, TOM-TOM TOM-TOM. Now Mama's mad. Mad. When Mama's angry her heart fills up with crap. Mama gets furious, vigorous, exhausted. I move off behind my vessels to escape her thoughts. At those moments when Mama gets angry I get hungry. Hungry. Mama refuses to let me get fat. From hunger my head of a dum-dum fills up with crap. Mama is transfixed with fear. Her foot kicks me. AAJB, I drag myself with unappeasable hunger, drag myself to dig a little hole in the ground and feel in my finger the tom-tom beat of my TOM-TOM TOM-TOM heart. Mama and I are always together in the house. We love each other sometimes in tremendous harmony. Harmony. I look at Mama to relieve my hunger. Mama's tom-tom heart wants to write some crappy pages (a piece of arm, breast, a tooth, my shoulder/ I can't stop myself now, I can't hold back/ fingernail, shoulder, it's really consistent/ my hand, my finger/ it doesn't hurt me/ it hasn't hurt me for years/ it's not true that it hurts/ a throb in the eyelid). She only thinks it, doesn't write it. Mama and I are together in the house in every sense. I exist only in a pile of papers. Clinging to one of my vessels I want to say the word "hunger," the word "hunger," and it doesn't come out. Ah, baaam, baaam, I laugh. I put my fingers in my mouth to bring out the word that broods among what few teeth I have. I'll leave Mama's leg in some hole or other when I get hold of the word I still can't manage to say. Mama's skin is salty. I don't like what's sweet, it makes you

4

fat. Makes you fat. I vomit what's sweet, what's salty is tasty. Now Mama's bent over, writing. Bent over, Mama begins to fuse with the page. To fuse. I want to bite her with what few teeth I have, but she doesn't know it. I want to bite her so she'll hit me in my DUM-DUM DUM-MY head of a dum-dum and leave that page. That page. When I can say the word "hunger" this story will have ended. I'll leave the vessel and grab hold of Mama's leg to hold in my drool forever. My TOM-TOM TOM-TOM of a heart says it. My salty heart that knows the taste of all things and the sufferings of all people. But Mama's a miser. Such a miser she won't offer me even a little warmth. Now it's cold and I turn blue. Blue. It gets so cold I turn blue and Mama says I look like a star. And it's she who shivers and contracts her sardonic mouth. Sardonic mouth. BRRRR, BRRRR, she shivers from the cold and I need a piece of ground to bury myself in. Mama doesn't let me because blue is pretty she says and says she likes to see me so peaceful. Peaceful. But I go off to my room and curl up. Mama follows me and tries to straighten me out with her leg. Her leg. She's got a savage bone in her knee and she gives it to me in the nose. In the nose. AAAIE. I bleed a little from the nose and Mama cleans me with her skirt and afterward puts a fold of the cloth on my nose so that I'll leave my blood on her skirt. The blood's warm as toast. Warm as toast. I lose a little of the blue. I get angry and break into a laugh that hurries Mama far off. Far off. If I turn bluer Mama will get happy and then I

won't be able to knock over my vessels. Mama's back is dangerous. I know it. Dangerous. Mama turns her back to me so she can get into those lying pages. Mama's back is bent by her pages. By her pages. The words she writes bend her and mortify her. I want to be Mama's only letter. To always be in Mama's heart TOM-TOM TOM-TOM and pick up its very beat. Mama hates my heart and wants АЛЛЈ to destroy it. But Mama loves me some of the time and watches me to sate her hunger on me. I laugh at Mama's hunger with a hearty laugh. baaam, baaam, the laugh leaps from my mouth into the first darkness I encounter. Mama runs to cover my mouth with her hand. With her hand. aaggg, I'm suffocating. I'm suffocating and I vomit on Mama's hand. Mama avoids my vomit because she reads my thoughts. She reads my thoughts and writes them her way. Mama wants us to be happy again in the letters she writes and that's why so much of the work is taken on by her back. Her back. When I do talk I'll get in the way of Mama's writing. She doesn't write what she wants. Mama looks around for me to go out on the street and freeze my head of a DUM-DUM DUM-MY. The street scares me. I like what little dirt's in the street. If Mama forces me to go outside I'll wound her with what few teeth I have. Now that it seems we're freezing I'll be Mama's only star. Mama goes out into the street to see the stars. The stars. baaam, baaam, I laugh all over the house waiting for Mama. With what little tongue I have I lick my vessel in order to bear the hunger. The

hunger. When Mama returns she presses the pages between her hands and turns her back to me. It's dangerous. But if I turn blue I'll please Mama who wants me to shine like a star. **BRRRR BRRRR** we shiver together and **baaam, baaam**, I laugh. Mama tries to cover her ears. Her ears. I climb up to her ear and **baaam, baaam**, I laugh, but she hugs me and with such cold I can't refuse. Refuse. In Mama's arms it feels toasty. I feel dark, dangerous, and toasty. Down below is Mama, Mama's skirt, and farther down an abyss of sorrows. Her grief makes me hungry. Hungry. Hunger stimulates my saliva. My saliva runs in search of a little something to eat. But Mama has forgotten food and tries to pull what few hairs I have. I fill with saliva and a faint laugh I've got left. Laugh. I **SCRRR** myself, scrape my face. **SCRRR**. It hurts. My cheek, maybe, hurts, and my nose, and I look for Mama's hand to pat me. Pat me. Mama cleans my hand on her skirt and looks at me. When Mama looks at me sorrowfully I cover my head of a **DUM-DUM DUM-MY** because I'm frightened by her face filled with terror. Terror. If Mama's face shows sorrow and terror I take her fingers and twist them so she'll forget the pages that separate us and invent us. In her pages she wants to murder my head of a **DUM-DUM DUM-MY**. Afterward I go far away thinking some words for my mouth that's dumb. My thought is near Mama and far from my tongue that's so full of saliva it's dumb. Dumb. I know that in her pages Mama destroys what little being she has left and that's why she has

legs and letters. Letters. Mama wants what few teeth I have to fall out so that not a word will remain embedded among my bones. She wants to break my teeth on her pages. She tries to break my teeth, with her back to me, so we'll remain floating and blue like despairing stars. Stars. Mama feels less overwhelmed when she sees me frozen and BRRRR the cold gets inside us and she knows that only her legs and the skimpy folds of her skirt heal us. Mama's bitterness is peeved with me and is placed amid the folds of her skirt and in the middle of her pages, attacking the most valuable part of her, and I grab hold of her to be her star. Her star. Mama needs a star so much and messes up my head of a dum-dum because I don't turn blue, as I ought. But my head of a dum-dum is going to start to freeze if Mama takes refuge among her pages. Pages. What Mama wants is for the man who writes her to freeze and if she succeeds in that we'll be united forever and my drool will be our sole consolation. Consolation. Mama sometimes feels peaceful on top. When she is peaceful on top she thinks the worst things and I start to laugh. Laugh. I love it that Mama has thoughts since it lets me concentrate on my vessels and scrape their menacing shapes. Shapes. The shapes are surprising. I look like a vessel when I turn blue. When Mama turns blue from the cold she asks me to put drool on her calf. But my drool turns thin from the cold and she gets angry and starts her feverish pages. I drag myself across the floor and make her look at me. I curl up.

Curl up. WAK WAK WAK WAK my head of a DUM-DUM DUM-MY falls in every direction. With what few teeth I have I scrape the floor and sometimes eat a little bit of some stuff. Mama takes the stuff out of my mouth and I chew on the fingernail she puts in my mouth. Tasty, Mama's fingernail. I want to say "Tasty, Mama's fingernail" and the words don't come out. If Mama sees me with my mouth open she tries to pull my tongue outside. She wants to rip out my tongue so it stays dumb. Dumb. Once I do speak Mama will tremble because I guess her thoughts. But Mama loves me and we stay together in the house between the cold and what little drool I have. The man who writes to her is not anywhere in sight. Mama has developed a hatred for his absence at the center of her thought. I know because I read Mama's thoughts. Mama's hatred is transferred to the most sinuous part of her skirt. Of her skirt. Mama's hatred swings from side to side in time with her steps. Because if Mama abandons me, I laugh and cling to the vessels she angrily keeps. If Mama's insolent to my vessels I surprise her with a new laugh I invent at that very moment. Moment. Mama knows I'm always hungry and need some food. She knows when I fall in the crack of one of the rooms. At certain times I trip over her leg from hunger. When I trip, Mama gets frightened and runs out heedlessly to get a little food. A little food that I chew with what few teeth I have. At odd times she gives me a few scant drops of milk. Mama's milk is the content she hides secretly. Secretly. Over the

years Mama keeps a little milk and controls it so it doesn't run out. It's Mama's secret. Mama's milk is as warm as toast. Crystal clear and warm as toast. But Mama preserves it for all the years of her life and lets me sip scarcely one or two drops and I want to ask her more, more, and the words don't come out. I remain with my mouth open to say "more" and my mouth opens wide and then Mama pinches my lips. Lips. Mama keeps her milk so secret. Mama preserves her milk to make her top feel toasty. Toasty. I know because when I've touched her top part it's toasty. Toasty and fervent. But Mama's a miser and pushes away my face of a DUM-DUM DUM-MY. An indefinite laugh comes over me. I laugh so many ways I succeed in putting my face to her breast. To her breast. Mama has too much rage and that's why she turns her back on me and returns to her pages so stubbornly. Stubbornly. Mama suddenly goes out onto the street and brings me amazing news. People on the street are amazing. Certain people know Mama out on the street by the faint milk stain she bears on her breast. On her breast. Mama's milk has a secret that I have to keep an eye on. This secret puts Mama in a bad state. Bad state. Mama remains in the bad state when she sees how hunger floods the streets. This hunger seizes her with really devastating force and there the most dangerous decisions pop into her head. Decisions. She comes back into the house and bestows on her pages the shame aroused by her going out. We fall against the wall in a movement that wounds my head of a

DUM-DUM DUM-MY. We fall and with what little sight I have I watch how Mama wants to get something out of her pages so as to forget the hunger in the streets. She leaves on the pages the little being left her. But now she has fallen without knowing it into who knows what point of hunger in the streets. She has fallen into the middle of an extraordinarily little-known freeze. And Mama and I hope that the man who writes her turns blue for the rest of his life. Of his life. Right now I'm turning blue, blue like a star, and I laugh with one of my best-known laughs so Mama will applaud me. With what little sight I have I see the drop of milk Mama's got left and my lip breaks loose to reach her breast, but I'm so frozen I fall. I fall. Very touched Mama feels we're close to heaven. She feels we're going to touch that heaven which for so many years she's awaited. Awaited. AAAIE, I'm falling. She wants me to turn blue, blue like a star, and bear her with the little being she still has left to the piece of heaven that will lessen the work of her hand and of her tortured page, will lessen the stain on her breast and the burning itch in her skirt. Entirely blue like a star I fall in the midst of an indescribable freeze. I fall looking for Mama who no longer sees, who turns her back on me, bent over the challenge of her uncertain page. Mama who remains far removed from the famine of the people in the streets because right now she lies lost. Lies lost and solitary and singular amid the stormy words that draw her near the meager heaven in which she could scarcely dwell. Now Mama writes. To me she turns her back. Her back. She writes:

Dusk
to Dawn

awn is breaking as I write. Your distrust extends even further the frontiers that stretch between us. It's turned quite cold. So cold it becomes increasingly palpable in this dawn and I have nothing to warm me. Ah, but that's impossible for you to understand because you, who don't find yourself exposed to this miserable temperature, could never comprehend this penetrating sensation that invades me. You must answer me at once. Just as I feared, your son was expelled from school today. Remember, I asked you repeatedly and, at times, desperately, to make the necessary arrangements to try to prevent this outcome. Now it's too late. The sky is beginning to turn infinitely blue, a blue that foretells the poignant arrival of a pallid sun that I can already tell will only more brightly illuminate the cold encircling us.

Your son's still sleeping. He's sleeping as if nothing had happened, since he depends on the certainty that you will continue to follow our hostile course at a distance. But, this time, you must understand this dilemma, which is also yours, because if you don't, our troubles will be yours and the peacefulness that surrounds your life will go forever untapped.

It seems to me that today the sky will be arrogant and vast. While your son shrugs off the cold, I suffer as if I'd been attacked by a noxious plague. I've never achieved even the semblance of

resisting it, and at this moment I've come to the conclusion that, maybe, my skin was designed perversely for winters.

The latest freezes have harshly devastated me, carrying me toward a malaise that violates the laws of any illness whatsoever. Your son, on the other hand, although he trembles, perseveres in the happiness of his solitary games, interspersed with his surprising horselaughs. He laughs openly during those hours when I've taken refuge, seeking a dream that will give me relief from the cold. I asked you to tell him, I warned you how much his games upset me. You didn't do it. In a few minutes I will bury myself among the worn-out blankets on my bed and I assure you your son will wake up solely to deprive me of the rest I need.

That's everything. Think how I keep hoping for the gesture that will remedy the whole lot of my discomforts. Oh, think too about the cold that penetrates every breach in the house.

ut how dare you write me words like that? I can't tell whether you're threatening me or joking. At what moment did your hand put forward such unjust accusations? You're mistaken, your son being expelled was entirely appropriate, and to me it seems cruel of you to insinuate that it was I who induced him to look for some way out of school. It was your son's entirely personal action, and I too, had I seen myself confronting the school administrators' dilemma, would have taken exactly the same step. What affronts I have to take from you. Now, on top of the cold, I'm wounded by your insults, of which you show not the slightest awareness. I repeat: the expulsion represents a lukewarm punishment of a breach that to me seems unpardonable. But how can you accuse me of wanting your son to give up his education? At this time, I fear that you don't even know your own son, and you refuse to recognize that his conduct was charged with a great deal of wickedness. What he did exceeds all limits, and I find myself facing a known fact that has left me more than ashamed.

Outdoors is plagued by extreme turbulence. I'm certain that, on this night, the sky displays an unusual scattering. It's as though each of the different darknesses were seeking refuge inside the next one and, at the same time, trying to break out. This is an oppressive and indecisive night. Never again do I want to receive from you any untimely statement or have you try to cast doubt on a decision that is

inevitable. Never did I ask you to set forth a pronouncement on the expulsion, much less evaluate my conduct. Really, I now understand that your letter was written solely for the pleasure of provoking my wrath. But the only thing that mobilizes me is the need to respond to the enormous dilemma we're living with right now. I fear the arrival of daylight. Your son wakes up with the light and torments me with his games and his menacing horselaughs. Those desolate noises come through the doors behind which I protect myself, taking precautions against his sickly sounds.

You can't know how, trembling with cold, disrupted by dreams, I press my hands over my ears so hard that I hurt myself. Oh, you don't understand what it means to live with his disconcerting horselaughs. Now I demand that you take back your words and limit yourself solely to giving me an answer. I realize that my tone seems imperious to you, but that's the measure of the conflict I confront.

During the course of this night it seemed as though the sky would bring about a catastrophe. Never have I witnessed an opening such as this. You trying to pull off some scheme is useless, so don't attempt to convince me that your son's pallor is becoming progressively sickly. The sickness you predict is confined solely to your pernicious judgments. Limit yourself to writing, with the good sense I expect, a solution to this tragedy that's proving interminable to me.

The whole night long my heart has harassed me without letup. During all these hours I have felt crippled, assailed by a truly disturbing weariness. A prisoner of diverse anxieties, even the most trifling, I could wish only for a quick death. But I couldn't guess that more punishments awaited me, punishments revealed in certain fleeting dreams about mutilations. In my brief dreams, a mangled body lay across my hands. Just imagine, I was the cause of that death, and yet I didn't know where the final resting place of those remains ought to be. I don't know how I survive that dream in which I saw myself astounded, holding some corpse's mutilated viscera for which I was responsible. My heart has humiliated me all night long. Hearts beat, beat, beat, but mine, during this night, was irregular. It beat in frightening arrhythmia. My heart has behaved in such a hurtful way that I'm in no condition to reply to the questions you ask me.

I know I owe this bad night to my neighbor. My neighbor keeps her eye on me and keeps her eye on your son. She has put aside her own family and now devotes herself solely to spying on my every move. She's an absurd woman whose rancor has vanquished her and left her prey to the power of her envy. My neighbor seems to perk up only when she sees me walking down the street, looking for some food. Then I come face to face with her eyes shamelessly following me from her window, with a

malicious cast to them in which I can read her worst thoughts. Then she goes out, and it would even be possible to swear that sometimes she has followed me. You know I have a keen sense when I feel observed.

I could swear that she has shadowed my footsteps on my only trip across town. Now I know my neighbor, in spite of the cold, is going from house to house, and I'm sure that I'm the motive for her rounds and the reason for her conversations. Her look is definitely tendentious, and I can sense how evil is creeping up behind my back, jumping me from behind, leaving me clawed by cruel defamations. I just don't understand from which of her innumerable hatreds she's chosen to make me her opponent.

You know that my own neighbor spies on me. The questions you ask me only reproduce the spying within me. Your son not attending school isn't a sign of our living together indecorously. I warned you this moment would come. If you haven't put a stop to it, why then must I follow your orders? We remain, we stay according to your will in a city that is progressively going mad. My neighbor keeps her eye on me and keeps her eye on your son, and when it grows dark I can hear her desperate weeping. She cries because her Western life has turned upside down, because the cold has taken another turn and, from its contagion, tonight even my heart has revolted.

Your son and I spend this time committed to a rhythm that doesn't merit the slightest reproach,

and I don't see why I should have to give you a detailed account of how we spend the day. But, in short, you must know that our hours go by mocking the cold that is reaching truly monstrous proportions. Your son wards it off by playing his games and sidesteps it with the clamor of his deafening horselaughs. I keep vigil by day and I'm vigilant during the night. But how can I make you understand that my neighbor lashes out at me shamefully? So quit wearing me down with totally unfounded arguments. Your son was expelled from school on account of his behavior and we are confined to the house. What is it you really fear? What harm could threaten people who live locked up between four walls?

h, my neighbor is looking to vilify us. Her pupils, always crouching and ready to pounce, never fail to show an incomprehensible fury toward us. Your son, who has understood, now also plays while crouching down. We are kept under surveillance by a woman who's been reduced to gesticulating flesh, a woman terrified of herself, who, with the power of her gaze, snatches a few moments of enthusiasm to ease her monotonous life. From her window she executes disconnected and to a large degree apathetic actions, a series of actions in which she scarcely conceals a stuttering stream of offensive words. My neighbor is the best representative of a city person's procedure that strikes me as increasingly scabrous. A procedure by which she stirs up the badly aligned chromosomes deep within her miserable anatomy.

The surveillance is extended now and encloses the city. This surveillance supports the neighbors' instituting laws, which, they assert, could curb the decadence they observe. They have taken up activities lacking any basis whatsoever, except to grant them some exercise that lets them get the stiffness out of their numbed limbs. Your son and I now move amid glances and an inconceivable chill. Nevertheless, you dare to doubt my words and thereby seek to excuse my neighbor. You accuse me of being the one responsible for a thought that, according to you, alludes to an astonishingly ambiguous position, or you claim that my assertions,

as you have stated, result from the anesthetic effect of a dangerous dream. Through your judgments you are trying to turn me into the image of a lying woman. A lying woman, driven by a mounting delirium. I tell you—and this you know full well—that your words represent the best-known and most treacherous way of discrediting me. In this way you refuse to accept that my neighbor spies on me and spies on your son, and at this moment it seems to me that you yourself have taken advantage of her sick staring to further your own ends.

I ask myself, what is it that prejudices you against our behavior? If I rightly understood your recent letter, you are disturbed that I want to foster in your son's thinking what seems opposed to your beliefs. You also say that I'm the one trying to lead your son away from a proper education, and you even go so far as to assert that it's my own conduct that arouses your distrust, since more than one neighbor has described my curious movements to you.

Couldn't it be the delirium in which you implicate me that really informs your writing? Could you be forgetting perhaps that I myself was the one who foresaw the school problem your son faced? And aren't you forgetting, as well, that my words were granted no attention at all by you? Your son was expelled from school and now I ought to concern myself with his education. I ought to do it in spite of the violent cold that grips the city in near paralysis. Oh, the cold continues and continues

slicing through the house, freezing even the tiniest corners. Your son moves amid this unacceptable temperature so actively that I'm always surprised. He runs through the house at full speed and, on occasion, he bumps into the walls. His bumps, however, don't alarm me. I have bumped myself too often in sudden falls, in unavoidable accidents, from legitimate distractions. His bumps, then, don't frighten me. What upsets me are his horselaughs which seem to multiply in the midst of this cold, as if he were trying with his laughter to defeat this unbearable freezing. Your son laughs with a noise as harsh to me as the cold that falls upon us, and he pays no attention to the malaise these noises provoke in me. I spend my days between putting up with his laugh and dodging the custody of my insistent neighbor's eyes.

But in spite of these obstacles, your son and I enjoy, at certain times, an extraordinary peace. A peace that seems to me more real, more permissible, and much brighter than the regulations that you, on the basis of I don't know what capitulation, want to oblige us to accept.

This dusk appears infested with threatening signs. The streets display a tone I find hard to describe. Oh, the dusk deteriorates and collapses with incredible drama. At this moment your son has fallen asleep at my side. His head shakes and shakes as if he were trying to wipe out the images of a terrible dream. I will cover his body with a wool blanket. I must look for a colored ribbon to put round his waist.

I feel immersed in an infinite night, full of threatening subterfuges. Your son doesn't fall asleep tonight and is playing nimbly, setting up a besieged space that no longer allows him any exit. Oh, if only there were someone with whom to share our open, wakeful, and reddened eyes. Now I begin to think that this night will never end, encouraged by a cold that I can't tell how much longer we can stand. The nighttime cold becomes astonishingly tangible, ruining my legs and my back, tormenting me down to the last bone in my arm. You'll understand, then, that writing you represents a superhuman effort for me. We have gone through all our provisions and I ought to go out on the street, at the point of day-break, to find some food.

You say a neighbor has informed you that a number of objects have disappeared from my house. Yes, it's true that I sold some of my belongings, but you know I have the privilege, if I think it advisable, of getting rid of my own property. You don't even provide your son's necessities and yet dare to meddle in the way I procure our subsistence. Your accusations are infested with shamelessness and I don't know what words to use to demand that you limit yourself to inquiring about only those matters that can foster the growth of your son. But, for your consolation, I'll tell you that I have gotten rid only of those objects that least held my interest, merely a few pieces with some small, visible defect and that always troubled your son. I've found out that

these pieces now adorn living rooms in some of the nearby houses and occupy the place of honor. My neighbors spruce themselves up this way thanks to your immutable indifference.

It seems to me that you looked only to deepen my suffering by maintaining and continuing to maintain that your son's expulsion originated in a web of deceits I deliberately implanted in him. However, I don't want to go over yet again this painful episode that betrayed your son's bad behavior.

You must know that although my affection for him knows no limits, sometimes I'm irritated by his mind. His mind persists in revealing a dramatic character that has something arithmetical about it. I don't know how I might explain it, but I sense deep within his brain a highly numerical process that affects my restraint. A process that misdirects his thinking and unleashes his irritating horse-laughs. It's hateful and vulgar for me to have to witness these operations that build up in his mind without the slightest sense to them.

Still, to his credit, your son has certain divine ways. He seems divine when he goes from room to room leaving aside his terrible horselaughs to perform small acts of universal value. His universal acts take root in his own body, and he performs them with all the versatility of a choreography created for condemned figures. It seems, at those moments, as though he submerges himself in some other time, in a time I have no knowledge of, that

I'll never recognize. I feel then that his is the most brilliant mind dwelling in the city. I grant him fantasies, dreams of revenge, oblique looks, babblings. I grant these to him fully, sacrificing the multitude of my own dreams, my wishes, to leave him lost in delighting himself with the next form our loneliness will take.

I advise you to stop feigning a worry you don't really feel. You know I feel threatened by my own neighbors and require the greatest tranquility in order to withstand their sudden attacks now that they have managed to turn surveillance into a work of art. I have to guard against your son's horselaughs breaking the laws that painfully protect us. One of my neighbors has a deformed foot and his pain gives him the occasion to adopt a cunning limp, a limp so faked it fills me with shame. As you see, I'm exposed to the siege of a crippled man. Don't you, then, be the one who ends up bringing our house down with your commentaries which you know dash my spirits as nothing else can.

I want you to understand that when your son's thinking gets twisted, this defect torments my soul. My soul also becomes twisted at such times. But you, although you don't live with us, take it upon yourself to inject my soul with the maximum dose of insecurity, and you seem to me more implacable than the lash of the cold.

I ask you to understand once and for all that I am writing you in a state of collapse. I

jeopardize myself by writing you. You should know what a state of collapse I'm in at every daybreak. The day is going to begin any moment now. I have to train my body to slip past the freezing cold out on the street. I'll go out on the street at some moment or other. I'll do it, you know very well, a little exasperated, quite secretively.

think you made a hasty decision. I still don't feel convinced that your son, for the time being, should go back to school. It would be too tiring for me to have to attend to these matters. The cold doesn't let up and it's turned circular. A night is beginning that predicts the coming of a storm. This winter prolongs itself and prolongs itself, violating its own nature, openly defying the other seasons. The fog does nothing but roll through the streets dramatically, trailing a wake of cruel omens in its path.

Your son cannot go back to school right now. It would be harmful to him and to me. I don't want to discuss this decision since your commands succeed only in exhausting me more than I deserve. How is it you don't realize that's asking too much of us just when we require complete rest? These last days the cold has reached unbearable levels and no one has given a convincing explanation for this situation. At this very moment an unredeemable storm will descend upon us. For me, the sound of thunder is shameless, but I'm sure your son will be able to outdo those sounds with his horselaughs. I can't swear that this winter's cruelty is worse than the games your son delights in every day.

I beg you not to start harping on his pallor again. As you know, children's skin is absolutely surprising. Your son belongs to that type whose balance is delicate, and I find it absurd and insidious on your part to attribute what constitutes the

core of his beauty to an illness. With your alarm
you only manage to hurt me, but I also understand
that the lack of confidence you show is nothing
but sophistry that masks your own indifference.
You have devoted yourself to fusing totally differ-
ent questions. For the present your son will not go
back to school and my decision is unalterable. The
disadvantage you point to doesn't exist. You have
only to delay the commitment you made. Allege
whatever you like about the new school until I feel
up to facing calmly this new phase with your son.

Outside an incredible storm has exploded.
If only you could see how a multiform battleground
is opening in the sky from which I'm getting some
despairing echoes. I'm witnessing a scene endowed
with an arrogance that may turn out to be lethal, a
limitless space in which irreconcilable passions are
argued. The storm frightens me, but, in spite of this
disaster, your son sleeps on, adding still further to
my displeasure. Your son, sometimes, laughs in his
dreams. He dreams in the middle of a laugh that
seems bearable to me, and, on those occasions, it's
been enough for me to go to his bed in order to
touch his brow, and my gesture has succeeded in
turning his laugh into a gentle moan.

I am weary and filled with uneasiness from
watching this storm. You cannot impose rules on
us whose fulfillment you won't be able to supervise.
Your son will go back to school when our condition
changes back. All this time you have shown yourself

to be excessively stubborn. Don't let yourself be blinded by the nature that governs your character. Keep in mind that I want nothing for your son but his happiness, and for him to go back just now to a suffocating atmosphere would only be one more cause of unhappiness. The burden we must bear because of the defiant surveillance my neighbors have taken up is already quite enough. I know you understand the logic of my decision. Don't side with a Western order that may end in undeniable failure.

h, Lord. Your persistence turns into a cruel weapon that you use over and over to attack me. You seem to have come out of nowhere when you decide to ignore how a family lives. You introduce a doubt that can't be legitimate and you take pleasure in questioning customs that even the tiniest of the animal species set up.

Your son is not attending school at this time, which means his hours are divided between various useful activities. You'll understand that there are other kinds of knowledge besides what school teaches. Your son learns, for example, the impressive dilemma presented by rooms, the mystery harbored in the distance separating darkness from light, the dimension and precision comprising the roof, the past proffered in corners. Why do you dump all your worries on me? What makes you fail to attend to the real problems I tell you about?

The real conflict we face rests with the neighbors and their conglomeration of intolerances. Now, thanks to them, the city I travel through, in a few hours and out of necessity, seems to me an unreal space, a place open to the operatic, the theatrical. A remnant of such proportions that I can predict its imminent liberation into anarchy. This upheaval is wholly attributable to the neighbors. They try to establish laws whose origin nobody knows for sure, though it's obvious they contrive this attack solely to increase the goods

accumulating in their houses. But I caution you with express clarity that these laws are debated in the midst of indescribable conformity and allude to such abuses that I can't tell whether or not they occur only in their minds. I feel that the neighbors want to perform a theater piece in which the role of enemy is awarded to those citizens who don't submit to the extreme rigidity of their statutes.

The neighbors maintain that the city requires emergency help to impose order on the wickedness running through it. They claim that the hand of God has abandoned the city, and I think that if that's so, it's only because of man's avarice. It's true that the main streets have lost all their prestige and that the most powerful neighbors now clamber toward the limits, near the mountain plateaus, in order to elude the nightmarish crisis. Still, what they are really concealing is their not wanting to belong to a devalued territory and their being prepared to take any means whatsoever in order to save themselves from a terrible humiliation. That's why they go from house to house spreading news of senseless laws. New laws that seek to arouse the amorous glance of the West's other side. But the other West is frightfully indifferent to any seduction and seems to view the city only as a threadbare theater piece. I know you've already learned that what the neighbors are trying to do is to govern without fetters, oppress without limits, judge without prudence, punish without respite.

Couldn't you consider how difficult it is to survive in such a besieged city? What do you do to make my life and your son's any easier? The fear you have of your son's flow of knowledge being interrupted is totally absurd since, on the contrary, it increases day by day. That ought not to be a source of apprehension. Rather, you ought to be disturbed by the surveillance the neighbors exert over our house and to do everything in your power to protect us from that morbid persecution. Maybe it's risky on my part to hazard a judgment of your behavior, but at times I think you're conspiring with the dangerous rules they're trying to impose on us; otherwise, you wouldn't always come back to the same topics. Your son is living right now what I consider to be his best time. The only thing holding us back is the virulence of this cold. Oh, the cold. It is so cold my hand gets cramped and my writing slows down. The words I write you are guided by frozen reason. Don't hold me then to more than you already hold me. Haven't you learned yet that human beings dash themselves to pieces against their own limits?

My hand trembles as I write you. Trembles as though a hurricane were attacking it in the middle of a wasteland. Your mother has come today to visit us as your emissary. But, tell me, was it really necessary to put us through a humiliation of this kind? Your mother dared enter our house looking for I don't know what kind of transgression in the rooms. At the time I was sleeping and it was your son who informed me of her arrival. Your son woke me in a panic since you know how he hates the intrusion of strangers. Oh, you can't imagine, but calming him constituted a real feat for me.

Luckily the fog has brought us a calming half-light that dilutes the factions' facial expressions. The fog today favored putting up with your mother's inquisitive face. I find no words to express the uneasiness and anxiety I've had to go through today. All these hours I've walked sleeplessly through the rooms, cursing you. Your son, after the visit, played so frenetically that it brought on the worst laughing fit of these last months. What gives you the right to allow yourself such actions? What wrong have we done to you for you to make us fall into this state?

Your mother's words harbor an insolence rarely experienced, an insolence veiled behind a deceptive facade of friendliness. Your son and I were ashamed of her conduct, not knowing how to comport ourselves in our own house. She even dared to

give me suggestions for increasing the light we've never wanted. To me the cold and the brightness seem totally incompatible. Your son—and I have so stated to you—takes more pleasure in the darkness. He has an extraordinary sense for finding all kinds of things in the shadows. Tell me, do you understand that? Can you understand that? Because, you know, it's a quality that in the future will help him get past the most difficult obstacles. Shadow brings us the scant happiness we have. But your mother, stubbornly set on destroying me, sought to associate our joy with pallor, which to her mind showed in your son's face.

At that moment I realized that even more than into your emissary your mother had turned herself into my enemy. Your mother, speaking with your mouth, alluded without letup to your son's pallor. To calm her down, I had to pass the terrible test of placing your son's face in the light so she could examine it. Oh, I still don't know where I found the strength to do it. Your son shuddered, clinging to my dress, trying to evade the light that dazzled him. Your mother retreated afterward, announcing another visit very soon.

I must ask you to tell her that I will not tolerate another such invasion. But, in spite of my words, I must acknowledge that your mother was extremely beautiful, shot through with a striking Western perfection, as if the cold didn't harm her either. I understood that between your mother

35

and your son there alternated a similar organic hierarchy. I wanted to talk with her about how they partially shared the same genetic value, but her antagonistic attitude quickly discouraged me. You've undertaken to plant in your mother a great prejudice against us. I announce to you that from this instant I shall lock all the doors of the house. As you see, your aggression can easily be diluted.

want to convince you that your rage has aroused an admirable notion in me. I will kill you. Yes. I will kill you one day for what you force me to do and what you prevent me from realizing—tyrannizing over me in this city in order to make sense of your own life, at the expense of my breaking down, my being silent, and my being obedient, which you have secured by means of your inimitable threats. It's inconceivable how you use your mother so that she invokes the name of love for your son with her eyes fixed on heaven. I will kill you one day to rob you of that power you don't deserve and that you have been broadening, mercilessly, ever since at the dawn of our precarious time you discovered that I was to be your beast of burden on which you would inflict all your abuses.

I will kill you in the shadow of a tree so as not to wear myself out while clutching the weapon I'll let fall upon your body an infinite number of times until you have been murdered forever. I wish to kill you at the height of a storm, so that your rasping death rattle will mix with the exquisite sound of a thunderclap's echo and your convulsions will resemble the pattern of the lightning bolt you threaten me with when you condemn me to bad weather, so that a lightening bolt will destroy me, as your mother has said, at the top of her voice, when the panic of a violent storm is unleashed.

Because, tell me: Aren't you ashamed of the gain you've gotten by managing our lives inside this

house from a distance? You expropriated all my decisions by making yourself the master of our steps and thereby you guaranteed your own survival. And I, I will kill you, you'll see—for these and other reasons I'll go on decanting in the cold of these days, continue mulling hour after hour, as I stretch myself along the haughty threads of minutes when I brave the temperature's cruelty. Because you must know this cold is cruel and devastates me and exhausts me even though I force myself to put up with it inside my infected body. You've taken up the old ways with me, ways that long ago had fallen into disgrace and been repudiated even by the powerful history of domination that was obliged to eliminate them as inhuman, relegating them to the history of barbarities. But you, you who had heard about these horrible practices, revived them with me in spite of knowing very well that the victims of long ago rebelled, and even though many of them succumbed, others achieved liberation and the defeat of these savage customs.

 You took up the ancient ways with me because you are hoping I will rise up to the point where my insurrection confronts yours and you can oblige me, once and for all, to match forces. But I shall not grant you that pleasure, because I know you don't know what forces move me, with what forces, which aren't yours, I maintain myself in spite of any and every climate's hostility. And that exasperates you, exasperates you so deeply that you,

someone who is extremely careful, let your doubt show in your letters and allowed to surface that pernicious need for me to confront you head-on as your enemy.

I shall never match forces with you and I shall go on accepting, with seeming resignation, this urban submission you have forced upon me, as well as the barbaric threats by which you demand my insurrection. My insurrection, for the moment, consists solely of certain long walks down the street, and even those leave you panic-stricken. But it's there, all the way down the street, where I collect the images that stay with me afterward, in nighttime solitude, and if you managed to surmise them they would leave you quaking with fear.

At certain moments I'll close my eyes in ecstasy, I'll dance by myself, ecstatically thinking of the moment when I must kill you fittingly and finally. I shall kill you in the midst of a wonderful woodland setting, protected by your son, who will stand at a prudent distance, affected by the precision of each one of the stabs with which I'll put an end to your existence. I think now, during all my half-frozen minutes, only about which death will be worthy of your body and which of all wounds will be within the reach of my hand.

must apologize and acknowledge that my words were hasty, precipitated by a clumsy, infantile fit of anger. I ask you to pardon my offensive, lethal images. The cold made me commit a terrible mistake. I beg you to intercede and save me. It's necessary to avoid coming to that foolish legal action your mother is getting ready to instigate. I have never tried to injure her, much less deprive her of her legitimate right to visit your son. I understand the effort she has made in crossing from one end of the city to the other only to find, at the end of her journey, our house locked. I know the climate damages her health and I also know that the streets are infested with the homeless whom she fears and that, to avoid them, she has to take multiple detours, which make her painful trip even longer. Your mother's health is delicate and you don't have to remind me that she must spend the greater part of her days confined to her apartment in order to reduce the anemia that ravages her. Your mother's blood has always proved incompatible with her organism, and it even seems that you forget how much I had to attend to her illness during that terrifying summer when the city was left almost uninhabited.

I recall your mother struggling between the suffocating heat and shivering, I recall her being hounded by a death that tried to lie atop her like an awkward lover who would have tried for an immediate and banal consummation. I would

never dare to maintain that I saved her life, since her survival was the marvel of a greater determination dictated by her own desire. Your mother, in those moments, gambled with death, moved by who knows what vain caprice. I was witness to her gamble and I saw her emerge the winner at the end of an exhausting wager. Your mother constantly outmaneuvers the composition of her blood and, in that unparalleled summer, put up the most critical struggle to purify her body.

I know your mother was getting fed up and that's how she gets over the monotony brought on by her considerable beauty. Just as she does, I consider her Western beauty a waste, since all it achieves is wearing her down by looks that scrutinize her as if she were a sacred object. Except for your birth, no blemish seems to have touched her flesh, and that forever deprived her of happiness. I understand how she amuses herself with death in order to feel alive and forces herself to admit contamination into the interior of her own organism. Your mother has always aroused the most caring feelings in me, and it was never part of my intention to block her entry into our house. But I can't accept the offer you make us. Your son and I, we've already settled how we will live. For your mother our company would simply be a greater disturbance to her health.

You ought to counsel your mother to give up and tell her that I'll accept her visiting us when

I have been properly notified. As for the lawsuit you advise me of, I have won it beforehand, because your mother is a sick woman. So to whom will the judges be disposed? But I confess to you that I'm terrified of appearing before the judges. I can't put myself through that humiliation again. Pass on to her my wish for her to come to our house and tell her I agree to everything she requested concerning how your son should be dressed.

You must communicate all this to her at once. I don't want her notions poisoning even further the difficult terrain our lives are passing through. Let's dismiss these sterile lawsuits once and for all. I want you to be sure that I shall never lift a hand against your body. Your son remains at my side now and has consented to each word I'm writing you. Right now he's wonderfully dressed in blue. Tell me: Why should you people find blue such an improper color?

ou glory in your extraordinary precision with words. You construct a real monolith with your writing, lacking the slightest hesitation. Your last letter is full of provocations, fraught with threats, encompassed by suspicions. A letter that, in the sum of assurances it expresses, appears brazen to me.

You and your mother, I understand from the emphasis displayed in your letter, see no other solution to our differences besides initiating a lawsuit. A lawsuit that separates me from your son and distances from him the man you refer to as my negative ancestor. But, what is it you're really after? Are you perhaps trying to fill your discontented mother with satisfaction? Do you think, even for an instant, that's how she'll get the position she needs so much? Why don't you pause to judge her conduct?

Your mother lives as though she were not alive, seeking an abstract evil in every corner, looking for it with an implacable will that seeks to destroy every obstacle in her path. I think that what she's hoping for, in reality, is to exorcise her own countless fears—the fear she feels at every corner, her marked fright at the possibility of a breach in any wall. And behind her fear lies the panic she experiences if you do not heed her words. Your mother, I insist, lives as though she were not alive, and that's why she's decided to envelope me in a series of lies. Because lies are what she tells you, deceits are what prop up the idea of this lawsuit.

Still, it's as if your mother had already started a lawsuit when she questions me: she searches, doubts, pressures me during her deliberate visits. Her body goes into a state of extreme tension, her hearing fans out, alerting her muddled brain mass and, sometimes, she even gets tongue-tied and the questions get scrambled in her throat. You mother, who does not live, merely inhabits the space of fear, her incredible tenor of losing her place as emissary. Your son has been converted into a pretext for acting out her unstable fantasies, and she pursues him and hounds him, and then shows her dissatisfaction with each one of his acts.

Your son defends himself and conceals from her the phenomenal development of his astonishing physical game. He plays at appearing and disappearing, his body presents and absents itself, falls and gets up, becomes tangled in itself, flees, escapes, awakens from a long vigil, sympathizes with the state of his limbs. With his body, he conducts a scientific operation that combines the most intricate paradoxes. Why, tell me, don't you think, as your son does, that the body is the bulwark of ceremony? He has understood the rarefied vocation of the body, and in his game he constantly makes pleasure clash with suffering in the same way that flesh and bone coexist. The ceremony goes forward, stops, settles in a portion of the organ. His stomach that throbs, his hip. The purity of the blind, visionary eye. A wonderful circular movement of his

arm. And suddenly, in an instant, your son's body verges on pulverization. When that happens, I grow alarmed and withdraw, but he later appears before me, pulled together again, as if he had never experienced a limit moment.

You know that your son's sedentary body battles against the nomadism of his limbs. But today I must battle with your words, I must rake over your expressions, while I maintain myself as the guardian of your letters in the midst of this cold that assaults the visible necessities of my body. I want to ask you to give up the threat, the suspicion, to seek a new diversion for your mother. What I am in truth asking is that you don't mention the possibility of a lawsuit again.

Ah, listen: in the streets they've set up the government for the section forbidden to the people. My neighbor goes through the forbidden section of the streets and, at this very moment, I observe him from my window. He approaches, limping in the midst of this relative darkness. The darkness that envelops him seems only to outline the marked shape of his deformity. My neighbor observes the movement on the streets stealthily, hidden, as if he had seen more than his eyes can resist. Then he withdraws and closes his eyes for a long time.

ow little you refer to yourself in the contents of your letters. If I understand your words correctly, it would seem that of the two of us, I am the one who is alive. And it is the life you concede to me that motivates your threatening me with a lawsuit which, according to you, will make public the sum total of my bad habits. But I don't live the life you assert that I live. Your mother's tricks, the stories, the suspicions, and her uneasiness are her own rages which she assigns to me. You two make me live, then, a life that belongs integrally to the wishes and fears that overpower your mother. I have wondered, from time to time, whether she doesn't present this fictitious account to you so as to prevent, in that way, your falling into the heart of a malignant solitude.

How is it that you are trying to make yourself the owner of a life you suppose is mine yet doesn't suit me? Maybe you don't want to recognize that you're bound to false words? Why can't you accept that for you my being is altogether beyond your grasp? Oh, still all I know is that you won't engage in a lawsuit with such weak proofs. If I choose to sleep at certain hours and not during the ones you require me to it's owing to a simple need of my organism and it's my organism that makes me prefer certain foods while I reject others. Similarly, how I relate to your son is strictly personal. It's true that the ties between your son and

me are not conceived as a show staged for strangers, but in our privacy we achieve splendid moments, when we succeed in agreeing that we inhabit a mutilated world.

No wickedness has crept into my behavior that might prejudice your son. You know that I am more inclined to good than to harm. The only thing that wears me down and displeases me is the way our son goes on with his games, how his amusement takes him to the edge of suffering. You can't imagine how much your son's horselaughs upset me—that constricted laugh, the terrible tightness in his throat. But his laugh doesn't justify your mother's attitude. She has confessed to me that she fears him. When she comes inside our house, her back doesn't seem relaxed and every few steps she turns around to see if your son is following her or if his figure is threatening her. So don't say your mother harbors the best feelings toward your son when she suspects that he may be her murderer.

Drop the idea of this lawsuit, don't try playacting before the judges the animal that escaped from his burrow. I know that a lawsuit would fill the neighbors with pleasure, those neighbors who would be overjoyed at going into court so as to follow the charges against me with uncontainable pleasure. Are you preparing a celebration for my neighbors? But it's your mother, I know it's your mother, who goads you into these ideas. I see in her a thirst that no one could describe and a hatred for

us that goes on perfecting itself, I don't know how, among the fibers of her tormented body. Maybe she aims at having me pay with my flesh the price her theatrical illness inflicted on her.

Your mother spreads cruel stories in the street that compromise and injure my honor. In passing I've heard a succession of exasperating rumors, an accumulation of lies that the neighbors repeat as if that whole farce had really taken place. You must issue an order against these perverse words. I'm warning you: my destiny isn't going to be to serve yours, even though you've understood the wonderful pliability of my organism and want to set up a strict conspiracy with your mother in order to make of me, in captivity, your faithful agent. But don't grow overconfident and be careful about how far you go with your actions. My feet are capable of assuming an inconceivable bravery and we will be at an inordinate distance when my human side has rebelled. Nothing about the act of fleeing frightens me. You know my body is capable of taking on an intense penance, and I can change my whole life in the most professional, primitive way that escape may require.

h, I cannot believe what you write me. Are you trying to drive us mad? How could we live in my parents' house? You know that my mother died when I was two years old and my father when I was scarcely ten. You know very well that I had a solitary childhood, wearisome and tragic. A wearisome childhood made up for, in part, by the wonderful landscape where I lost myself for many of my hours. It was there, among the trees, that the most beautiful of my images came to me. Sheltered by the leaves of the trees, I foresaw that one day your son would come into my life. In those years I was very careful about everything I offered him; I dressed him, fed him, took part in each one of his games, and, thrilled, watched over his irreversible growth. I scrupulously cared for him during each illness. Your son was born, then, in my mind before he was born in my body, and that makes him doubly mine.

In the natural world of the forest I precociously forged the tone for what would fashion my nature. Woods are similar in substance to God. The first time I went deep inside them, I saw how the sky was disappearing amid the dome of the trees. The trees stood for the memory of a time immemorial and there, outside and within time, I fully understood the fragility, all the impurity borne by my species. Without a possible sky, I confronted a cold I could associate only with the vault in which I would one day lose myself forever. I found myself,

absent any sort of shock, chilled by the foreboding specter of the death offered my body while still at the height of its growth. Oh, I recall vividly how I walked through the middle of those woods with deep pride and a deep-seated feeling of love for myself.

But, I am not trying to exhaust you with my memories. Your son's cough is only an effect of nerves brought on by the disturbances your incredible requirements produce in him. Besides, you know very well that childhood incubates all illnesses inside an organism that is tackling the exercise of living. Stop bothering me with your worries. The only thing that seems uncontrollable to me is his games, which will end up driving me mad. You've asked me to describe them, but it's impossible for me to do so. It's his relation to objects that provokes horselaughs, which keep spiraling up and up. Now he coughs and laughs and laughs and laughs, as he darts from room to room chasing something that escapes my eyes.

Your mother comes regularly and then leaves in strange haste. I don't know whether her behavior annoys me or pleases me. It's your son who refuses to see her, and I am unable to keep him from locking himself in one of the rooms. Your son knows the most extraordinary tricks when he wants to lose himself among the rooms. He disappears right in front of my eyes. Forcing him to stay would be a punishment that under no circumstance does

he deserve. If your mother doesn't resign herself, then suggest to her that she give up her visits. Or perhaps I should say, her inspections.

Nevertheless your mother doesn't stop. Neither the dawn nor the wildest hours of dusk stops her. Not even the power of my scorn stops her. She doesn't even respond to the imperative of her own weariness. But you shall not be the mirror of your mother. Stop suggesting changes to me that I haven't asked you for. Your son and I live in perfect harmony. I think it's appropriate for you to put off writing for a while. You don't resolve anything; rather, you hinder. Don't worry that we'll escape your surveillance. You know I have no refuge other than my house. I free you from any obligation to us. From now on, live in peace. Free your mother as well from her unnecessary difficulties.

You continue to lie in wait like a ferocious beast of prey. At night I imagine you with your teeth glinting, ready to pounce on us. In the end you stripped me of the last thing I had left, of the only thing that gave me relief: you deprived me of sleep. You deprived me of sleep in order to achieve your triumph over my body that's teetering on the brink of a cataclysm. I don't sleep to protect myself any longer, or if I do, my sleep is nothing but a constant convulsion. I know that my parents are alive, you know perfectly well that my parents are alive, but, for me, my mother died when I was two years old and my father when I was scarcely ten. I don't want to dwell on this subject now. How could you, then, oblige us to live with a couple of ghosts?

You emphasize how imperative it is to write letters and my obligation to answer your letters. If I don't write you, you say, you will make a final decision. I see that you endow writing with a sacred value, and in that way you include me in your personal rite without my difficulties mattering to you, except perhaps for the pleasure it gives you to take control of my days and the laborious calligraphic incident that occupies my nights.

I ask myself: Will you ever have suffered at some time or other such a drastic dawn as the one I confront at this moment? I don't know by what pact, after what collusion, total power has been conferred on the cold, since the form in which

hatred against our unprotected bodies has been unleashed these days is made visible to my eyes alone. In your letters you take away all the climate's importance and thus cancel out my words as you push me toward a deed that the cold keeps us from committing. All right, it's true that when your mother comes to the house we appear drowsy and the order of the rooms has been changed. Perhaps we breathe, eat, move about less. How could our activity amount to so much, when this freezing cold reduces us to the condition of simple organic elements? Even your son, whose vitality I envy, scarcely plays these days, almost to the point where I would say that in his games the motions occur only in his mind. His external energies are concentrated on changing the order of the rooms. He moves the furniture into the center of the rooms to minimize the bad weather. Then he takes refuge in the tiny spaces left by the armchairs, and I can hardly hear his laughter that, fortunately, is muffled by the wall of upholstery.

When your mother comes, she trembles visibly at the same time that she raises her endless complaints: the cold, she says, the street, the danger in the streets, she says, that I prod her into exposing herself to the risk. And she says a lot more, all the while trembling as she asks me to kiss her frozen cheek; trembling she also orders me to rub her limbs which are numb, she says, and then she undertakes a diligent inspection throughout the

whole house. Oh, your mother and her rapacious gaze, her stealthy steps as if she wanted to surprise the performance of an incredible scene on the other side of the thresholds. And I have to follow her feebly, halfway between my own trembling and her shivers. I follow her because I fear that her despicable tour might break the peace behind which your son takes refuge. Your mother speaks to me, points out, accuses, and disparages everything her eye falls on. She reproaches me without consideration, as if she were the inspector of an orphanage in ruins.

She says, how can she fail to say, that only her selfless duty to the family motivates her, that she will overcome the cold, will overcome any and every obstacle in order to protect your son from my bad ways. That a lawsuit, she says, might not only achieve the physical well-being of your son, but more particularly might liberate his spirit. "A lawsuit," she says, "you deserve a lawsuit." Oh, what a sordid trail we trace in the imperfect couple we make.

Your son, fortunately, slips away among the furniture and there eludes her words. But his horselaughs give him away and give rise to another string of complaints showing your mother's real motivation. My worry is that in reality she detests your son. After all, except for you, she has remained out of contact. Do you recall the resentment aroused in her on being inconvenienced? But I shall not be the one to judge your mother. I only hope that she ends this frightful siege, at least as this winter draws

to a close. Today it dawned as though it had not dawned, since the sky is smudged, scarred, I would say. Oh, I don't know what words to use to describe this sky to you. A herd of hungry animals. A sinister, unattainable dome collapsed back upon itself.

Voices can be heard in the streets, noises and movements that confirm the climate's beginning to change its sign. The oppressive weather is finally drawing to a close. Even in your last letter a subtle shift could be discerned, as if you had understood at last the reality of the problems I have laid out to you. Your mother, these days, appears silent though no less stormy. Oh, I feel that she's a woman surviving who knows what dark cataclysm,which has usurped, forever, her capacity to reconcile her strengths, reducing her to nothing but her addictive precision in regard to enclosed spaces.

Your mother changes in our enclosed space. She changes, I imagine, since it stirs the memory of her own catastrophe, so, despite my being completely ignorant of it, I can still manage to detect her spineless form and receive its effects tangentially. But your mother now appears silent, she presents herself to me with a pallor that fills me with awe. With that Western pallor she goes through the house (goes through it a little less irritable than before, a little abstracted, goes through it as if she were not responsible for her steps). Then she leaves mumbling the start of a phrase she doesn't manage to finish, in the middle of one final, scornful look. Once she is gone, your son comes out of his hiding place and I understand that he has created a new game he's going to solve with infinite counting.

After her departure I go to the city's downtown areas and there I observe the neighbors exchanging words that proclaim outlandish actions. You no doubt are aware that these days they declare their support frenetically, taking increasingly unfortunate positions. I am weary of listening to their ravings, but I cannot escape hearing schemes I can't believe in, brushing elbows with people I detest. The neighbors terrorize themselves, and in spite of their wishes the city is falling to pieces, falling to pieces in the solitude of its destiny. How the fissures are deepening can be seen clearly. I see sections that are falling down and I also perceive that it's Western arrogance intertwined with fear that preserves this kind of facade.

The neighbors struggle indefatigably to impose new civic laws that will result in the creation of another sealed cordon. Then we will be pressured by rules not backed by legislation unless it comes from the multiple impulses driving the neighbors. They've demanded that I endorse their plans and they've ordered me, categorically, to attend the meetings they hold in their houses. But I couldn't, I don't want to lend myself to their cunning. I know they are in pursuit of an immaculate city, which is nonexistent. If they achieve it, if it can be achieved, it will turn me into just another element in this crude surveillance. You will understand now why I reject the neighbors and that it's not owing, as your mother has said, to my hoping the city will crumble once and for all.

I shall not attend their dark meetings, nor shall I give my consent to the establishment of these armed surveillance patrols they propose. I have informed you that one of my neighbors limps frightfully, but even so, with that defect, he roams one part of the city, his very being shattered by weariness and bitterness, hoping to find I don't know what sort of corruption when dusk breaks loose. Sometimes I believe that the circular surveillance he's created is merely a pretext for exhibiting his limp. If they've decided to put guards back on the street, I don't see why I ought to go along with them in their undertaking. I tell you categorically not to hint that it would be positive for your son if I join this group of creatures who are so obsessed. If you so highly approve of the latest measures it could be your mother who represents you. The neighbors proclaim that it's indispensable to take custody of the West's destiny. Tell me: Has it ever occurred to you that the West could lie in the opposite direction?

The sun continues to assume a greater presence day by day. The streets are recovering their urban status and again capturing physical footsteps. It's said that this last season's cold finished off many of the homeless, although that's a vague rumor, whispered with a lot of caution. Yet it's repeated each time I venture out to look for food. The homeless, according to people who live at the city's fringe, succumbed for lack of shelter, and near the end they headed toward private homes, seeking help. Word has it that the neighbors kept their doors locked in spite of the pleas, and that some of the homeless froze to death, propped against front doors. This sun must be a kind of miracle, then, for the survivors.

I have thought that maybe they chose my house as a place of refuge. Some nights when the temperature turned critical I thought I heard some faint knocks at the front. I was never alarmed by those sounds because I attributed them to the bad weather. No one has died in the doorway of my house and there may not be the slightest basis for these reports. In the city, every so often, alarming reports are repeated that inflame the neighbors' conversations. Rumor is part of the noise in the street. I have not yet adjusted, either to the rumors or to the noises. Making myself into a city dweller has been a painful discipline.

It's true that the public shelters closed a long time ago; it's also true that today I saw fewer

homeless on the street. But something like that couldn't be. Not a single one of the homeless could die forsaken on the sidewalks. I beg you not to mention my parents again, much less your son and me keeping them company. My parents ceased to exist for me many years ago, and your demand turns out to be completely impossible.

From the contents of your letter, I know that now you fear me and think that I am your antagonist. You and your mother fear me because you intuit the state of my feelings. The state of my feelings comes to pass in extreme solitude and the solitude of my feelings is an advantage. But your intention has been to deprive me of all that's mine, leaving your orders deposited in my blind brain. What you are trying to secure is that the validity of my own story won't even be recognized. I tell you, to me you resemble a miser whose entire fortune has been stolen, and he runs out distraught in search of the booty with which he justified his existence.

All right. Let's soon define the origin of the pallor that, according to you, devastates your son. I accept your son's being auscultated by the doctor you specify. I've already warned him that I have had nothing to do with this decision. It will be just as you say, as you dictate. If you require such a price for averting our appearance in court, then that's how it will be. Now I understand how you achieve the equilibrium you have so desired.

The peace that surrounds you results from your seeing to it that we live in the midst of constant fright.

I am so agitated. An outbreak of ugly news is spreading underground in every isolated corner of the city. They say that an undetermined number of the homeless met their end during the last freezes. Rumor has it that whole families died with their bodies huddled together. They've told me that the children had their eyes open, as if before dying they had glimpsed God's omnipotence. According to what the people who live along the fringe say, the women died, in contrast, with their eyes shut, plunged into an expected, solitary darkness.

They tell how families perished lying against the entrances to public buildings in the hope that the doors might open to save, at least, the children. They say that during those nights custodians double-locked the padlocks and zealously secured the windows. Rumors have it that the victims' bodies were removed under a cloak of secrecy that cannot be attributed to the practice of mourning but rather to a disturbing impunity. The only official reports they have given us emphasize that the public shelters will not be reopened because the sun's advent makes that unnecessary.

The sun has brought out the little greenery to be seen in the streets but, while lovely, the color of the flowers seems less brilliant to me. The reds don't match and the yellows are muddled with ochre. The leaves on the trees are also noticeably smaller while the trunks show considerable

62

cracking. It seems that each season has aggravated an extreme danger since now another terrifying rumor is spreading through the streets: the water. They say the water might be contaminated. But this piece of news is surely false, merely a cause for alarm and perverse amusement among the neighbors.

If the water were tainted that would be the same as affirming that life itself is at risk of an imminent end. Water is the sole relief from the intense heat that's already noticeable. So how could the water be tainted? It's the heat that makes people delirious, the drought crazes the neighbors who take pleasure in transmitting a panic that further alters their thirsty bodies.

I don't want you stating yet again that your son destroys everything he finds in his path. The destruction you have pointed out is only part of his games. I have told you before that he plays with objects as if they were obstacles he ought to clear away. Nothing with a speck of value has been destroyed. And the neighbors' complaining to your mother about the noise of your son's horselaughs seems despicable to me, since I have never protested against the terrible, ominous positions they have put me in. I have tried everything to stop the horselaughs and it's been impossible for me. Now you'll see how his growing up will put an end to this annoying habit.

Since you ask, it's possible that in the coming months your son may return to school. But I don't

want us to get ahead of ourselves. We'll decide when the right moment comes. I believe that you shouldn't expose your mother to this miserable heat that's coming; it isn't necessary for her to visit us so frequently now. Look, peaceful weather is forecast. During this summer why don't we embark upon a kind of truce?

This summer has me confused. I know a disturbance in nature has taken place.

It's an extremely delicate operation that I can't grasp, but the evidence for it is in the colors, the textures, in the slanting breeze that cools the afternoon. Signs so subtle that when I feel I have found a proof for my surmises, the colors approach their reality, textures their origin, the breeze the tide that exhaled it. But, nevertheless, the turbulence exists, it's just that it sustains itself by mutating, by an act of camouflage that bespeaks a trap or chaos.

This season makes my life even more oppressive. I walk the streets in search of food, feeling as though the sun were capable at any moment of turning itself into a dagger seeking to bury itself in the nape of my neck. With this fear I cross the city with my right hand protecting my neck, and then the implacable sun shifts and falls on my brow, only on my brow, making me intolerably hot. This summer blinds me severely. You know this is an unusual feeling for me because I've always thrilled to summer. I would joyously greet the water that refreshed my body, I would see the burst of colors as a part of my own mind, and the heat as a remedy for ingratitude. Now, instead, I am at odds with the climate, nothing in it recompenses me, it provokes only my sustained bewilderment. I understand that the seasons have subtly changed their ways, creating new laws that my organism rejects. So I live days that go by in vain. Tonight is no different. If you were here you'd notice

a disturbing prostration, as if the sky itself had withdrawn, leaving a paralyzed copy to replace it. Oh, how futile it seems to me, sharing this season's changes with you. You seem devoted only to the summaries your mother gives you, and you disregard whatever dampens my spirit. You say your mother insists that your son and I eat at inappropriate times, that our food is casual and lacks the proper consistency. You say as well that, according to your mother, we have forgotten those Western ways normally observed during meals.

I don't know how to respond to those accusations. We experience meals as a challenge, and maybe it bothers your mother that we ramble through the rooms, depending on the quality of our food. But that's only a game requested by your son. He likes sharpening his sense of smell and asks me to put it to the test. It's not a loss of all principles, as you assert, for him to guess by smell what we eat. It's true that he eats, sometimes, with his eyes closed in order to predict the substance he's eating, but, in this way, he has achieved extraordinary triumphs, distinguishing vegetable from spice, or how the wheat has been processed. Oh, I feel proud of your son on account of his marvelous skill.

It's impossible for his training to injure him; it's not fair of you to impugn his ever-increasing knowledge. Remember how you yourself distrust foods; you know how many times you've felt afraid of being poisoned. Are you attempting to have

your son reproduce your illness? To prevent your transmitting your fears to him, I sought a way to minimize them. Don't tell me you want to impose a regimen on us that extends to meals. I know you won't do it, and moreover I know that in your letter you exhibited an uneasiness that isn't your own but comes from your mother. Your son doesn't like this sun either. He stays shut up in the rooms as if he wanted to avoid being witness to a growing anarchy. He also has noticed that nature is oscillating, and he appears opposed to entering upon a season whose rules he doesn't know.

In your letter you ask me about the frequency of my dreams. Oh, my dreams. Further on I must tell you at length about my dreams.

ou declare that my genital conduct gives rise to the most shameful comments that will entail grave consequences for your son's future. You also say that I dare to make my house into a space open to the lechery that intimidates your son and turns him pale. You assert that the neighbors are stupefied by what they regard as my outrages. I can no longer recall what else you refer to in the letter that just today you had dropped into my hands. But, for once, you haven't wounded me, and I shall not go to the trouble of beginning any sort of defense.

Late afternoons distress me since I'm aware of how the lessening of the light diminishes me. It's true that late afternoon is the most difficult time of day, since in those hours existence becomes bound up with infinite repetition. You also repeat and obscure and diminish the acts of my life. In your letter you devote yourself to studying the dusk of your own words. I had to decipher from the obscurity of each one of your sentences the will to cause me deliberate pain. To assert that I devote myself to wasting my body and that a man moves through my house, entering stealthily and leaving as the following dawn approaches, is to accuse me of having a lover I don't recognize.

Your words ramble on when you go along supposing trysts, writhing bodies, moans, that exist only in your own delirium. The lover you invent turns out to be a faithfully imagined double of

yourself. The neighbors accuse each other of every-thing that can be turned into an accusation. They live in order to spy and be spied on, maintaining an incessant inspection that resembles the crossfire typical of certain bloody battles. Parents spy on their children, children on their mothers, the male stranger on the female, the familiar woman on the unfamiliar. You seem to be the neighbor who would have been assigned to me in this feverish redistribu-tion. What your eyes don't spy on, you turn over to the surveillance of your imagination which dares to testify, from a distance, to a clandestine scene that supposedly occurred in one room of my house.

How could you know what my body needs in the presence of a body you've never known? What leads you to think that my language might get out of control to the point that you assert? Why should I have indulged in such sordid actions as you describe? The neighbors swallow rumors more voraciously than the food they eat, but I confess to you that up until now I had never received such despicably detailed information. So yours was the voice I needed in order to understand how vile-ness can become highly diverting. Don't give the neighbors credit for what is solely yours and reveals that you've set in motion a new plot that, most certainly, will be seconded by your mother. You're sailing in swampy waters and will end up with mud sealing your mouth and leading to asphyxiation all the way to your brain. You resemble those vermin

that grow in the stagnant water of swamps and wouldn't know how to survive outside the marsh.

Well then, if that's how you see things, your son will be interrogated about the men who come into our house. One of these days the horselaughs will end by shattering him. Your mother will sport her most beautiful mourning dress and you, what will you do then? Just tell me when the interrogation of your son will be conducted and at exactly what hour your mother will appear in court.

The right to run my own house has been denied me. Very well, I shall give you an exact account of the facts. The "men" to whom your mother and the neighbors have tendentiously referred were some of the homeless I took in during those nights when the cold reached impossible levels. I ask myself: Why should I have been obliged to consult you about my decisions? Death was so close at hand for those bodies that my action was desperate. They had already lost most movement, had lost even the ability to speak. Giving a little shelter for a few hours cannot be the offense that motivated the start of the trial with which you have threatened me from time to time. If I committed such an unpardonable breach, don't worry that you will ever hear a similar report. I shall explain in detail to your mother each one of the reasons that led me to make that decision and I know she will understand them and thereby calm her spirit.

I didn't want to offend the neighbors by breaking the agreement to lock our doors against the homeless. Perhaps it really was dangerous, but those beings were already so incapacitated that none of their gestures could have been mistaken for violence. The possible contagion, the unseemliness of their appearance, the disasters, as you see, never revealed themselves. Your son and I have not suffered any consequences. Perhaps it was rash on my part, but I have already said that I shall never behave that way

71

again, and if you think it necessary I shall make the rounds of the nearby houses to explain my act. I assume that the assurances I offer you will excuse me in your eyes and that I will calm you sufficiently so that you will abandon the idea of a trial.

Your son has discovered a new diversion: only vessels interest him now. He orders them oddly in his room and afterward slips among them with marvelous synchrony. When he contemplates them, he laughs and I feel as though he would like to smash them with his horselaughs. He appears to be engrossed in a singular challenge that no one would have imagined. The games your son makes up seem more and more impenetrable to me, and I no longer understand what place objects occupy and what relation they hold to his body. The vessels are strictly arranged at the center of his room, forming a figure whose principle I fail to understand, much less its purpose.

I have tried to explain to your son that the vessels are not suitable for his games, but he looks at me as though he doesn't understand my words. I don't know how to stop him anymore and I suppose it's a question of a passing whim against which I should test the extent of my patience. Sometimes I've thought that in the vessels your son sees human forms to whom he shows his contempt; at other times, I imagine that your son attains a complex abstraction that brings him close to the realms of magic or science. But certainly this is a game in which accumulation alone has priority.

It seems to me that today will bring the end to hostilities: rumors have died down, it has been confirmed that the quality of the water is at its highest, your son is losing the pallor that so upset your mother. School will open its doors to your son at the next enrollment. It will therefore be sensible for us to avoid contact. There's no longer any reason for our continuing this limited and disturbing correspondence.

We are being consumed on account of you. I no longer can tell if I'm living or merely surviving as a solitary exercise. But even so, you have accused me, giving my name to the neighbors. You asserted that I have something of the homeless about me and you predicted that I'll end up wandering the streets interminably. How could you accuse me? Could it be you don't understand that by now you've given great power to the neighbors? A procession of self-satisfied citizens has come by demanding all kinds of definitions from me. Each one hastened to say his repugnant words, to express a repugnant anger, to exhibit his repugnant opinions to me. "I have the reputation I deserve and I lead the life I lead," I answered them, and such a sickening silence ensued that I understood that I had obtained a certain advantage. I told them that awful lie because it was necessary to halt the venomous flow of their words that had me at the brink of madness.

The neighbors are hunting down the homeless and have established a miserable agreement with certain individuals who will serve their ends. They came to my house ready to convert me into the first victim, to use my body as proof of the soundness of their plans. They pounded the door knocker with extreme arrogance, as if they bore in their hands a royal edict, and then they allowed themselves to name me the ringleader of a dubious urban irregularity. My neighbors' malevolent satisfaction seemed to

consume itself in my name, as if in that way they had given a name to the numerous homeless who fringe the city.

You have turned my neighbors into your allies so as to achieve what you cannot bring about yourself. The neighbors have been transformed into hunters of prey, terrified by everything that threatens their spaces. They think their spaces are threatened by the hunger roaming the streets, and I'm not sure whether it's a rumor that each of them has mobilized in order to fight their own boredom. Surveillance is the activity that keeps them alert; rumor, the proof of all their certainties. They've come to my house and treated me as though I were a homeless person myself. Their inspection, as they call it, was backed up by the fears you passed on to your mother, who acted on your behalf. They feared that I was allied with the homeless, they said that a conspiracy against Western harmony was spreading across the city and that all its homes were on the lookout for an insurrection that still hadn't assumed a clear form.

I admit that I looked at them dumbfounded until I saw their will to destroy. I understood how hatred was taking shape as they searched my house for proofs, signs that would confirm their fears. You have turned into an accomplice of a horrible enterprise that will be carried out at any moment. I know it because they are getting every kind of weapon ready for next winter. The neighbors will make next winter a bloody season.

You have accused me at last, and with your accusation you have caused me such a serious affront that I shall see myself obliged to settle our differences justly and definitively. You have vented your anger onto me, when all I have done is seek a possible existence in life. You have accused me, and I presume you're adding to the list my neighbors require in order to overcome the lethargy in which they find themselves enveloped. It's true that my life situation is extremely difficult, increasingly difficult, but that doesn't make me the same as a homeless person. It may be that at certain times I have strolled through the city in order to pass the time, but you know very well that I really do have a house and that you are the one who has turned the impossible into an accusation that's probable.

Those who accuse me emphasize that they issued an order making it imprudent to go out on the street at specified hours and that I was breaking the hard-won agreement they had reached. They told me I should correct my breach. You contrived for the weight of still further surveillance to fall upon my shoulders. The neighbors tried to communicate their decrees to your son, but he slipped off into one of the rooms and then became absorbed in a game that made me think of a cannibalistic act. Your son, it seems, now remains trapped in that game since the vessels surround him in dangerous precision. He is lying in the midst of his objects like the captive in the square who is preparing himself

to mount to the scaffold or the stake, trembling slightly, as if he had noticed a funereal atmosphere spreading through the streets. But you should know that he alone is devoting himself to acting out what you have given us: because you have given us a nightmarish scene, the path to crime. I suppose you understand now that with your accusing me we enter upon a critical phase.

The days are making my organism terribly ill. The nights damage my brain with dreams that drag me toward the other world where I don't live. You say I've been seen in the city performing acts that humiliate you. You tell me that the neighbors talk and that it is your mother who passes on to you the neighbors' shameful talking. So you want me to detail for you what my walks through the streets are like, and it is you yourself who tells me that if I don't, you will multiply your accusations and make me notorious in the case that is to mow down my life. You make me understand the materialized nearness of death and your incessant way of seeking to cut short my life.

There is nothing secret about my passing through the city. I go and come according to material necessities essential to caring for your son. The knowingness that I display in the streets in no way represents lewdness. My knowingness is peaceful and maybe generous in the extreme. The lewdness that you say you're attempting to eradicate in me belongs entirely to you and no one is better qualified than I to testify to that. Your lewdness is to be found skillfully disguised amid the seeming rigidity of your orders, but I recognize it and you suffer when you see that you will never be able to pervert me.

Certain days are hours of my long walks in the streets, but certain sections of the streets lose their reality and make me feel that I'm taking part

in a dream. A dream in which I stroll overwhelmed, losing my balance along stretches that twist and turn and distort me, threatening to crush me. But in my dreams space becomes irrationally passionate, irrational spaces whose offer of happiness shows itself to be so absolute that my pleasurable moments seem horribly insignificant to me. I then walk in a state of great agitation, fleeing my dreams that appear even in daytime spaces in order to assault me in the city.

Some sectors really seem almost inharmonious to me. The deterioration surrounding them can become alarming, and I'm witness to the neglect they suffer. They deteriorate in different ways; on the other hand the maladjustment my own organism often suffers is self-same and sinister. What happens to my knee is synchronously connected to my shoulder. Sometimes I feel as though all the fragments of my body were conspiring to paralyze me and leave me at a dead halt from one moment to the next.

I want to tell you one of my recent dreams, in which I confronted one of the most convincing corporal visions. I dreamed that my tongue condemned to moistness touched others (this happened in the city, in one of its most uninhabited sections). I received between my lips flesh that generously offered me its irregular surface. In this street dream my eyes closed against a cheek, my hand felt the thick length of an eyebrow, and my shoulder rubbed against a torso's solid frontality. During the dream I

could appraise the beauty of the contact by recognizing, finally, my body in a different body, and I understood then the exact feeling of each one of my parts and how my parts cry out for different treatment.

During this amorous sensation I was able to separate the pupil from the concavity of my eye, my leg from my ear, my neck from my forehead. Now I know that my neck is not solely raw material for decapitation, nor my eye the passage to blindness. I understood from the wisdom contained in my dream that my flesh is not merely the trail enabling you to take the best hike.

Oh, how could I explain to you, given the limitations inherent in words, the experience of achieving perfection? I lived through an incredible street scene in the course of my dream when I leaned my head against a wall. I saw there the dreadful need of my lips and their taut skin, my back alienated by my crazed nerves. I gained the certainty that shuddering is not condemned only to a notorious movement but also can be outdistanced in a startlingly short time.

I knew that there are marked differences among my fingers, owing to their differing lengths and the way each one of them assumes its individual independence when it slides along seeking its own form of pleasure. But there's more. I also knew that fingers can fuse with the most demanding leg muscle, and in that conjunction bring the lips to produc-

ing a grimace that obliges the teeth to institute a punishment. I now understand better that my teeth have the absolute power to attract to me the burden of beastliness which, instead of protecting itself, turns its nearest flesh into the enemy.

How could your mother and the neighbors set themselves up as judges even of my dreams? There is not a step of mine, as you see, that injures you, much less offends your son. In this letter I allow myself to take a great liberty with the dream horizon in order not to see the agonizing tragedy you are fashioning. Because, tell me, what is it you dream about? Oh, but I know. I think no difference lies between your dreams and reality. I assure you that in the images woven in your nights your son and I represent only the incandescent and repeated scene of an immolation.

hy do you keep harping on the homeless? What estimate do you want me to make for you? I can't recall how many homeless I took in, I don't want to retell the history of those days. You accuse me of hushing up a piece of compromising information. What's more, you blame me for deliberately lying. You insist that I have committed a breach for which you can find no way to express your repudiation of the extent of risk to which your son may have been exposed. You decide it's no longer possible for you to trust my ability to maintain the integrity of the house, since the fact that I sheltered the homeless alerts you to other possibly threatening actions. In short, the tone of your letter points to your having withdrawn your trust in me and to the urgency you feel for your son to live somewhere that offers him secure conditions.

I understand when you say that the homeless try to destroy the order respectable people have taken such pains to build up and that I am only making myself an accomplice of this disorder. It may be, as you assert, that the homeless increasingly head out in order to avoid performing their duties, that they are extremely dangerous rebels and, along with the insurrection their presence signifies, their bodies are riddled with the worst infections. You speak of crimes, of breaches, of ethical disruptions taking place on the streets, massive aggressions that, according to what you say, are

traceable to the homeless. You think that the only defense left to us is to turn our houses into fortresses, since the city has already been transformed into an impassable space.

I hadn't thought, I admit, of what you seem to understand so well. I had nothing in mind other than the terror of facing beings condemned to certain death. If I hadn't sheltered them, their end was a matter of hours. I didn't see in their bodies that deliberate insurrection to which you refer. I noticed only the cold, the terrible consequences of cold on totally destitute organisms. Doesn't the fact that they have taken to the streets speak in turn of their losing their homes? Explain to me, why did they have to lose their homes? My questions must be pointless, and more than pointless, useless. What I saw in them were victimized figures, unsteady survivors of I don't know what mysterious war. As you see, I opened the door then to people who bore the stigma of the dying.

But if all this is recalling the past, if you rely on my promise that this will never happen again, if I have offered you every assurance as a guarantee, isn't it only right to think that maybe you're stretching a fact in order to achieve an objective predating the blame you place on me? All I'm to blame for, and I hereby call it to your attention, was not informing you from the first moment of what was taking place inside my house. I was afraid to do so, and now I understand that it was senseless

on my part to mention what was going on with the homeless without telling you the extent to which I was involved.

But you can't condemn me to losing your son because of an error prompted by the fear that the presence of death aroused in me. I don't know how to prove to you the good faith of my intentions. From now on I shall turn the homeless into the very image of the enemy, I shall go along with the neighbors in all their decisions, I shall take the same detours your mother knows about in order to avoid the sight of any homeless person.

You see now that your son's clothing that bothered your mother was burned in her presence. She and I have now come to an agreement about the foods your son should or shouldn't eat. Your mother—and I have accepted this—has doubled the frequency of her visits. In my house you can depend then on a figure not even your personal attention could achieve. Be lenient toward my only mistake.

Your son can live only with me. I am watching him right now, and I note that he's working himself into a new game. I know it because his face is totally absorbed, going round and round with strange pleasure as if in search of a new order for his vessels. Tell me then that you will not act on your threat. If you say that, I shall make of my Western figure what you have always wished. I shall be another person, an other, other. I shall be other.

ou tell me that I've placed myself outside the law, and what you don't tell me is that you've placed me within reach of your law. You say, as well, that after the unacceptable incidents I have been involved in, your son and I are already talking the filthy language of the streets, and the neighbors have reached the conclusion that we waste the whole day and night.

You recall that you alerted me, on repeated occasions, to the way of preventing the disorder to which I'm inclined and that you did the impossible to make me understand what learning your son ought to acquire, what to reject. It's true, you emphasize a lot, numerous times, what learning ought to be rejected, especially which ones to reject. Your plan centered on teaching us how to look, so that we would never want what we didn't see. You wanted to keep us at all times with eyes averted, cast down. You went so far as to assert that it's really intolerable to show how much a look can contain the intensity of a feeling.

Oh, I still don't understand how, in the end, your surveillance managed to triumph. Your mother, who, among all her innumerable phobias, is afraid of anyone's gaze and is the brutal guardian of every gesture, one day dared tell me that she knew with which imperfections I had come to dwell on earth. She asserted that disorder had been inherent in me since birth, and on that occasion, before leaving the

house, she preached decisively: "From being born in bad conditions."

The couple you and your mother make was united as one in order to keep watch over your son's growth but, in reality, I say that you two became one in order to stop your son's growth. You don't fool me, not even for a moment. If your hand were stuffed for exhibition at the center of a fair, it would be like some bird of prey's claw, clenching its objective tighter and tighter, concentrating its membranes into the prehensile. Your claw and your mother's claw already figure in my nightmares. I see their curved shapes destroying our bodies, causing us to disappear among the lusts of a sick purity, seeking to obtain a legendary glory from our remains.

But your son inhabits a world where your premonitions are suspended. He plays self-absorbed among his vessels with a serenity that fills me with calm. He plays an exemplary game that consists of a harmonic numbering multiplied exponentially. His intelligence shines, it surfaces, and it too multiplies while he regroups the vessels and composes an extraordinarily beautiful visual figure. I see in the figure something like a face that, still and all, is not exactly a face. It seems more like a flawless landscape. Oh, your son plays flawlessly, grouping his vessels and unaware of your dangerous intentions. A mixture, solid and liquid, attends him, as though the vessels were dissolving the very nature of their

ceramic. Oh, your son plays in such an intangible way that I can't completely decipher. I play at unraveling your son's game, unmindful of the rumors spreading through the streets that place those occupying the fringes in a catastrophic position.

Your son is now bending over the vessels, weary after his difficult speculation. And now the time for his laugh begins, and with his laugh, my own weariness. Weary as I am, I'm not able to respond to the single question that seems to matter to you for settling our differences. Oh, I can't respond. Oh, God, you tell me that if I had a response you'd grant forgiveness. But, I don't know what I could tell you: the truth is, I have lost the certainty of knowing anymore what is named when the West is named.

think, I do nothing but think about how many homeless were in my house. What they did, what they said. But I don't succeed in fixing the events in my memory, since in those days the weather was uncertain and everything came down to the cold. The cold was falling into cycles that seemed more and more paradoxical to me, causing me to doubt the weather's sense and order. Five or ten homeless, I suppose, came here. Oh, but I don't know. What I can say is, it continues to be an indefinite number to me.

If there were five or ten of them it's evident that they occupied all the rooms in the house. No, it couldn't have been, they gathered in just one room and the only conversation I held with them turned on the cold and the stamina to bear it. At no time did they besiege your son, and he stayed in his room, concentrating on the ritual of his games. During that time he was dividing his interest between vessels and clothing. I recall him that way, since he was constantly taking my clothes in order to move them into his room, and it cost me a lot of effort to take back some of my garments from there. That habit annoyed me beyond limits so that I reached the point of hiding my favorite outfits, because I feared his hands might damage them. But your son, right away, discovered my hiding places, and I immediately understood that for him clothing was something arising in a part of his imagination that needed to be curtailed.

Your son seized clothing as if the garments were capable of seducing him or bribing him or making him share in understanding the human condition. His gaze harbored the most abstract point of his intelligence. An intelligence understanding that the essence of the body's comedy is concentrated in clothing. I observed his strange shudder when he ran his hand over the fabrics, turning round and round, with an impulsive laugh that wasn't even his. It was a symmetrical game that drove me to the brink of despair and one day fled from him as though it had never existed.

But you ask me to render you an account of how long the homeless people stayed, you ask for it precisely today when I have to reconstruct facts from different times. Now that the heat's showing its feverish signs, you turn me back toward the cold, to the memory of a coldness whose retreat invites my forgetting. I know that once the freezing weather receded the homeless left the house. It's true, they left at an hour that guaranteed their not being seen: I made sure of that so as to avoid rumors in the neighboring houses. Once they were gone, I forgot about the episode entirely.

I'm trying to recall what we talked about besides the bad weather, and I have no memory of other conversations. You ask me if I provided them with food and I answer you, yes, I gave them some kind of provisions. But they were meager, requiring no description, and in no way did they compromise

either my food or your son's. Yes, it's true that some of the homeless were young, but what are you trying to say when you question me about the ages of people who were at death's door? What you assert is not legitimate. It doesn't seem admissible to me that the neighbors might be preparing an accusation based on what doesn't constitute a crime. If it were as you say, I think they'd be positioning themselves outside the authority conferred on them by law, obeying an order you yourself have issued.

Why not give me a reasonable length of time, and I'll give you an exact description of the homeless people's every movement inside my house. Allow my memory to improve, think how hard it is for me to go to sleep since you have multiplied your requirements. Give me a little time to rest and you'll have your report, the report you'll surely send to each one of my accusing neighbors.

t strikes me as amazing how you go about arriving at your erroneous conclusions. In your letter you tell me that the doctor diagnosed your son as the victim of a general insufficiency. I didn't hear a single phrase from his lips that would point to such a diagnosis. What's more, I observed him calmly running his hands over your son's body like someone performing a monotonous routine. Your mother seemed to be expecting a genuinely organic catastrophe, and I noticed a slight disappointment in her eyes when the examination ended without any prescription. So then, what does it mean to speak of general insufficiency? Your son, to my joy, enjoys a state of health that keeps him in fine fettle. And it's quite true when I say that his games are the best evidence one can turn to for confirming his resistance. I have told you that the vessels take up all his time and seem to obey a mind at the height of its greatest powers.

The vessels are grouped in his room, and with them he tests the most rigid orderings. Your son and I have locked ourselves in a complex rivalry. He proposes riddles to me that I must solve. I know there's a key, a story, a rite, a mise-en-scène, a provocation in each of his arrangements. Sometimes the arrangement of the vessels strikes me as astonishingly analogous to the plan of the city. I see in them the solemnity of some public buildings, the insolence of uncultivated sites, certain remote houses; I intuit traps set especially for urban vagrancy. It's as if the

whole city were taken away and put back in another dimension, a city transformed solely in stylized scale, which nevertheless retains the greatest exactitude.

But when I tell him: "It's the city," your son laughs and I realize that I've made a mistake. I think then of the vessels, on the contrary, as certain of your son's own qualities, concealed beneath a solid layer of simulation. I perceive the strength of some of his feelings. His feelings seem so intensified that I have been touched to see how he can express passion. How your son's passion echoes within his own boundaries, blindly striking against his borders, causing a crash. I had not seen so clearly the frightening audacity of that feeling or ever witnessed its astonishing vigor.

"It's your passion," I tell him. And your son laughs and laughs and I collapse trying to evade that laugh that marks my failure and the pleasure of his success. But he laughs and then I fear there's been let loose a torrent of sounds that also may lack borders. After sating himself with his own laughter, he calms down only to take up a new ordering of his vessels, and I withdraw exhausted to my room. I withdraw to prepare myself for a new challenge, to consider what kind of game your son's impenetrable mind will construct.

The insufficiency that the doctor has diagnosed, according to what you say, is one more invention among those you've frequently communicated to me. I know it's an intentional lie, an instrument

for discrediting me and thus clouding my faithful devotion to your son. Oh, but you know that I know what you are attempting, that I grasp the key to your games more precisely than the riddles your son sets me. Because it's obvious that you command an ordering in which I am the sole piece and, at the same time, the counterpart of your game. So let's play: What should I do about your son's insufficiency?

Your mother has peremptorily told me that the time is coming when I must deliver the report I promised you. It's true, the deadline will fall due inexorably. But until then you must abide by the designated date and wait for the delivery for the report that will exempt me from appearing in court. I don't know if you will appreciate what I am going to venture, but I had a vision or an illumination or an inspiration while walking the streets in search of food. It was an unexpected thought that came to me from outside my feelings, an involuntary image but, still, of uniform simplicity. I saw in that image that your mother and you, although opposites, represent two sides of the same coin.

lright then, I have tired myself out. Let's forget this comedy for good. You know perfectly well what's happening in this city and to me it seems useless for us to shield ourselves behind a nonexistent innocence. I will reconstruct for you the homeless who spent the night at my house. I made my report with great accuracy and perhaps it may have ultimately misled you. If you can manage to set aside your host of prejudices, you'll see that you're not going to find anything that might compromise me unless it's the handing over of some signs that may strike you as surprising. Just as you bade me, I'm taking great pains with the purpose of ending your intimidations once and for all.

You must know that the homeless long ago fashioned their own story. A story sprung from I don't know what profound satisfaction. I took part in their stories during winter's coldest days, living side by side with creatures proscribed by the shelter laws. You will say, finding a reason for your animosity, that I made myself one more among the homeless, and then you'll be horrified and repudiate me and curse the day when our lives intersected. I imagine your mother satisfied by what she'll call "my confession," I see you delivering my letter to the neighbors, and I see as well how they'll rush to the public offices so that a suit may be brought against me. In the eyes of the authorities I shall have not the slightest chance of being exonerated. But this

moment would have arrived sooner or later. You know perfectly well that my fate is unalterable now, and I prefer to move ahead in order to please my vindication myself.

What I shall tell you will be for me the repetition of the oldest visions with which I fell asleep when I was a girl. So prepare your eyes and your mind for a long journey. But I hope you'll understand that mine was longer, more intense, more complete. So it doesn't make any difference that I paid for them.

But what story do I have to make? How can I manage to make my words convincing? Here I give you a sketchy account of the events, and afterward I'll refer to what the neighbors' panic has unleashed. Will you have the necessary patience? I opened my house to the homeless as soon as they knocked at my door. I disobeyed orders, as you see, without the slightest hesitation. (Later I had to repeat the gesture, exalting in my heart, knowing that your absent eyes were now keeping watch on me.) I had already foreseen that they would appear before my eyes one of these nights, and I held myself in expectation of their arrival each one of those nights. I don't know how long they put off coming to me, I don't know because by appearing they blotted out the time I had spent waiting. Two entire families revealed to my eyes the profound misery coursing through their bodies. Starving, absolutely frozen, they crossed the threshold. I provided them with everything they

needed. My God, their forms looked magnificent against the firelight. It was a kind of resurrection that took place in front of the flames. Their bodies regained their vigor, their breathing its rhythm, their joints their full power, their humanity crossing the children's faces. (The children occupy a special place in my memory, since I came to the conclusion that I had never understood what a child's face was: the incipient aging, the sickness, a wickedness that wounded the absorbed geometry of their brows.)

When I supplied them with warmth I suddenly found myself face to face with two unknown families. Oh, how defenseless we remained with no knowledge of what awaited us beyond the fire. Hunger began to occupy a central position in the room. Hunger was right there. (How to make you understand that I saw the aura encircling hunger?) A mass, a disturbance, a moan, a wish, a sharp demand that made me tremble. Oh, right there in front of me the powerful, ravenous hunger of those bodies. I cast down my eyes while they ate. You know my spirit is fragile, but I became more fragile in those moments. I seemed to be witnessing the scene of a forest reduced to ashes, a forest growing back thanks to the powerful conjuring of a wrathful enchantress. A forest stirred by the memory of its recent death, a forest that had replaced its most injured parts which were going to end up strangling it, murdering it a second time.

I know you'll feel besmirched, that after my words you'll denounce my birth, but it will be only a hateful illusion, scarcely a prejudice. I recognized my need to wash their bodies. I undressed them one by one and, with the finest linen I kept at the bottom of the chest, I sought to find the true skin that enveloped their skin of privation. It was a quest, a knowing, a mutual trembling. The women gave themselves over to my hands as though I were a lover, or a divinity, who was soothing them. The men as to a servant, the children as though they dwelt in an unborn world. The water took on another meaning when I washed my own arms with the cloth. My arms had grown weak. The night grew forthrightly generous with us. You will understand that that was a night disposed to beauty.

They left at dawn. I remained absorbed in a kind of vigil. I went to your son's room and for the first time was able to speak to him about the ingratitude as well as the perfection borne by the universe. Like a wise man he understood my words. Your son began a game that brought alchemy to my mind. I knew that someday he was going to succeed in solving all the problems. So there you now have the first elements for my condemnation. I have wearied myself. I shall continue tomorrow night. Another of my neighbors has shown herself increasingly haughty to me. Will she be the one who thunders with the heavy knocker on my door?

My very being quakes, agitated by the disturbing darkness surrounding this night. My entire body throbs, intuiting the form my sentence will take. Your son, who stirs at my side, now plays only on the defensive, cowed by the danger hovering over our heads. When I look at him, he appears to have been left behind by the multitudinous ordering of his own vessels. Your son seems to be seeking a line that demarcates the horizon, and in his eye there's traced something like a scar that, nonetheless, has its stitches in place. I want you to know that a few hours ago your mother, with a malevolent glint in her eye, informed me that the authorities have reached an agreement and are hastening to start, against me, one of the most extensive lawsuits in the city's criminal history. She says as well that the cause was backed by an association of powerful neighbors. What your mother kept back is that you are judge as well as party to the case that will be sealed at the cost of my life.

I know well that the letters I write you are building up part of the evidence, and I have reliable reports confirming that some of the homeless will be mobilized in order to accuse me before the court. Don't think these reports crush me, since I crossed the threshold of my own resistance a long time ago. Your son doesn't let up laughing as I write you, as though he knows that I am drawing up my sentence.

Tell me: In what evil moment did you that all this would take place? With what promises did you buy my neighbors? What will your mother and you do when I disappear? You went along weaving a net any trapper would envy, a net of such fine threads that even I am amazed. I fell prey to your voluminous net since I was incapable of guarding against how far your rancor had spread. Were you walking around thinking about the final moment of my fall? Were you laughing? Were you relishing in foresight the shape of my bones? This final moment that draws near, has it come to pass exactly according to your wishes? Oh, even though I fear you're not understanding what's happening, I won't say a word to you about the latest information I've gathered while crossing the streets, even though I jeopardize my own survival that way, because, after all, the desire to stay alive no longer directs my days.

You will turn me into the perfect victim since mine will be a trial outside history, whose convening is going to mark the arbitrary and malign sign of the times. Oh, but I can foresee how you will bide your time all that while, taking cover behind a cowardly obscurity, pulling the strings of the trial. While this trial lasts, your son will be interned in one of those sordid institutions that take in children. Through me, the mighty will discipline the citizens on the fringes who do not bow blindly to your demands and, in that way, your son will bear the label of orphan.

It seems to me that one part of the city is growing distorted, as though it had been dyna-mited. Could I be the one who is losing my own stability? Finally your distortion has wounded me and leaves me little to argue in a case invalidated beforehand. This summer ended without greater consequences, except for some pestilences that are affecting the surrounding sectors. Once again a rumor is circulating that the water is transmitting endless infections, that the epidemic, they say, that the indisposition, that the hunger grows and grows, that the children's doubtful resistance, that they no longer know how to segregate the sick from the healthy. The water along the fringes has turned toxic. Should I be concerned about the water? While water circulates foully through the city, your son and I are waiting for a resolution outside the laws of urban nature. It is wholly your nature that controls this abuse. I address you then as if you were a divinity in order to ask you: Tell me, why didn't you wait until the water could do its work on us?

oday my day will be deadened by illness. I move, breathe, stand up. I move. I write you. The smallest bone in my right shoulder has pained me with decided steadiness. This pain affects my hip and my right hand. So I am receiving a serious bodily warning. I feel oppressed by the discomfort from my body's compression in bad posture last night. When I move, the urban landscape is outlined in my pupil within the beam of light that's slowly diminishing the opacity surrounding us. I move, breathe. I do not end by getting up, despite the day ending its lowering.

I breathe, move. My hand writes numbed by the cold today, as though it were obliged to render account of an implacable persecution in the streets where bodies are strewn in the violence of blows that bloody them and disperse them. An unheard-of attack on emaciated bodies that flee cursing their bad life, their worse fate. A sizable aggression against a multitude flailed to atoms by panic, pain, and blood, shouldering their suffering as a memorial to blows while they flee terror-stricken at the punishment. A group pursued the length of the avenues, a forced dispersion that leaves some fallen against walls, and there more blows and blood again and perhaps the final wound in the head.

But I continue writing lightly as in an interrogation carried out with cold instruments on the man captured in the middle of the night, solely in

order to afflict his body, which, although it goes on breathing, will end up mutilated after the passing of more nightmarish hours than will ever be imagined by survivors. I write you slowly, as that man breathed before the mutilation, subjected to the worst humiliations human beings could inflict on human beings.

And my hand moves warily, like that of a child savagely beaten by his progenitors, a child who hides his bruises in order to shield the poverty of his parents. And my hand again moves slowly (it is a painful movement), like a dark, barren space, an unplowed land where they abandoned a bleeding woman who scarcely perceives that her assailants are going away, since she is moaning, lost in the depths of her thoughts. But, in spite of everything, I must go on writing you, even though doing so may compromise the fragile structure in which my body has awakened today.

Pierced now by a sudden bodily pain, my recollection travels back to the moment when your son was born. The moment when he was born was totally unfavorable for my body, and your son had the enormous fortitude to fight the resentment that coursed through my organism. He fought magnificently, and we both were able to survive by cheating the destiny our debilitated blood imposed on us.

But now I submit to forgetting and I straighten up, rising above this considerable pain, and I succeed in reviving my good wrist. I know this

is a terrible dawn for my back, wearied from bending over in order to write so many useless explanations. Oh, but your negative feelings toward us grow by dizzying leaps and bounds. The sun now appears entangled in a shifting zone intertwined with a consistency that seems marvelous to me. Through my window's opening I manage to catch sight of my neighbor, limping severely as he makes the rounds of our house. It seems as though he had nursed his anger even before learning of the new measures governing us. I watch him limping, limping, limping, silhouetted against a landscape that grows increasingly harsh.

Your son, to my good fortune, still retains all his vigor and today seems far removed from the threat of a double sentence. He wakes up alongside his vessels and looks at me and laughs and begins fusing with his vessels. Oh, if only you were able to witness his movements: your son is fusing with one of his vessels, his hand fighting to contain his heartbeats. Your mother will show up at any moment and will observe your son's game and blame me, and once more the horizon will threaten.

What kind of a trial is this going to be when I won't see my accusers? Tonight I ask myself: Who really is the recipient of my letters? Puzzled, I ask myself: What office do you hold and what is it that your mother has represented? Oh, my hand struggles to find a meaning amid the terrible nebulousness that invades the city and has caused it to lose all its features. I still can't understand the panic unleashed by the hunger and why the authorities continue to proclaim such rigid laws. I see that the neighbors are resorting to their final means of making themselves masters of all our habits. Your mother, my nearest neighbor, even tries to correct my behavior as though she were a child's tutor. She criticizes my language and forbids me to express any sentiment not in accord with what she calls "the splendor of the new era." I don't know what splendor she invokes, but I'm certain that your son and I are still unacquainted with it.

I know that you officially declared that I maintain a seditious alliance with the homeless, and I know, as well, that your latest demand is for me to confess fully, in the course of the trial, what motives led me to evade the regulation governing the city. You insist then in hiding behind blindness and making me, through a ridiculous crack, a dangerous social rebel.

You already know that the homeless arrived a first night at my house and that later I had to

repeat over and over the gesture of opening the door. (Your son and I, decided accomplices in this, united as though a single figure.) They were leaning in the doorway, their breathing fitful, and looking at them I imagined myself the spectator of a classic cavalcade across rocky terrain whose savage and rank undergrowth fatally wounded the riders who strayed from the road. A mob of riders galloping blindly through the lashes of stabbing branches that jab them in the face unmercifully, drawing blood that blocks their vision. Amid the dizzying gallop, I could make out the faces of the homeless, those faces I had already noticed in the course of a repeated bad dream. A dream foretelling death dealt by the wrath of an archaic hand.

(Your son and I serene in the doorway, admitting those ill-treated bodies.)

When they came, I thought that they had been picked up as from a shipwreck into which, on top of the water's cruelty, there burst the astonishment and panic embedded in a body contested in its own boundlessness. I saw them quivering like a fire or at the moment when a frightful accident erupts or at the height of a physical death rattle that shakes the vital organs collectively, lowering the vital signs alarmingly until reaching corporal nothingness. I received them as one greets misfortune or fear, as one might drain a futile hope, and at that my heart wept for the disparity that tracked my own destiny.

As I opened the front door for them, I thought I heard music foreign to the staff, an incomprehensible ritual sound, some lovely words murmured amid the cold cutting across the highland, a sort of announcement signaling that the agony had already turned endemic. I recognized in the music a still unhealed wound that chose the plague's power with precise cruelty. With my heart weeping, in full flight, I prepared to confront the miseries encircling the Western fringe.

It's true, the words I am writing you will never be understood properly. My vision, during the last winter, was devoted to those bodies that arrived at my door like freaks, survivors of countless painful experiences.

They said: "The city needs our overburdened figures in order to perform the sacrifice."

They blamed the egotistical architecture that governed the city and that in them reached its maximum omnipotence. They spoke of the existence of a sanctified plan that tried, through its organizations, to provide a punishment to pacify the physical disorders brought on by human inequalities. They said that through inequality the neighbors abused the name of God in order to carry out actions that blended the sacred, the bloody, and the omnipotent. They asserted that someone was using the name of God as a savage deathblow in order to conceal hunger, and that if there really were a Heavenly

Eternity it would be found only in the feats of their difficult existences.

I seemed to be witnessing an unexpected scene when I perceived that they felt themselves to be majestic despite the misfortune of their flesh and insisted on impugning those who sought to monopolize the decay devastating their figures.

They said: "God has never recompensed us or appeared in any form before our eyes."

My heart wept every one of those nights over the inhuman decision that infected our city. Your son changed his laugh slightly in homage to the fallen and converted his vessels into a stage for the duel. But you know well how the neighbors continued to be absorbed in perfecting the ritual of surveillance. And we had to fall. We had to fall into your hands, accused of overstepping laws that you imposed on us. We had to fall, but my heart still persists in sustaining me. Your son wanders about thinking of our salvation by means of his vessels and asks me to decipher the beautiful geometry in which he moves. Tonight gives signs of being dangerous. I feel now that a deranged star seeks to reverse the light's magic.

t a certain moment this afternoon the trial began. Could you yourself be the one in charge of the voluminous proceedings? I know this accusation is not supported by proof, since it is based only on a set of suppositions that will serve to alleviate fear in the city. They have kept me in custody for two, three, four, ten days. The neighbors maintain this fierce surveillance over me because they give assurances that I converted forever to being a rebel. They are supporting this frightful spiritual witch hunt in order to award themselves a moral glory they don't deserve. And there you are, leading the attack: restless, wavering, obsequious. Oh, how hard you have strained to achieve a standing that covers you with prestige at the center of this secondary West. You always sought to be prominent and that's why you pushed me into a seclusion that hurts me more than the nearness of death. It's true that I no longer distinguish between judges and neighbors, neighbors and authorities, do not understand what position you hold among them. I no longer know anything.

The neighbors were set on buying me without money, seducing me without features, flattering me without knowing my desires. But you always understood that I was not going to capitulate, that I would never turn into a maniac for the West. The neighbors now flaunt a lamentable moral uniform and fancy themselves the heroes of a myth. That's

possible, but a distasteful myth, an exploit that gives offense to the hunger in the streets. But the hunger persists there, growing like a greedy larva. There'll be more, and more. You who know that very well pretend not to know it at all.

The words I'm writing you may come to be classified as anarchist; a rabid coalition will assert that they're unintelligible or brazen or unfortunate. I only want to state now that I never wrote letters to you. I simply wrote to find out how my words failed. You and the neighbors were appropriating a great many abstract goods. They turned themselves into masters of the worst instruments. They obtained a uniform, a weapon, a club, a territory. They obtained it by flooding the city with countless banal slogans: "order not disobedience," "loyalty not treason," "modernity not barbarism," "labor not laziness," "health not sickness," "chastity not excess," "goodness." They said it, they yelled it. They lied without compunction when they maliciously ordered the circulation of their last rallying cry: "The West can be within your reach."

When I found out, I couldn't believe it. But there were the groups, the neighbors, your mother swelling with pride. I admit that I thought it was all part of a game, that I was the victim of some misunderstanding. But one day I understood the legitimacy of the panic that had possessed me the whole time. I grasped then that the insurrection wasn't in me, wasn't in the hunger in the streets; the insurrec-

tion they feared so much was in the will to wreck the West at any price. The obscenity of this conduct hurts me. It is the only thing that hurts me.

I shall emerge unscathed from this vicious trial. You don't really exist, you occupy a merely abstract position. I'm looking now for a way across the asymmetry of this time, escape from this useless collection of prejudices. We haven't reached the end. Your son and I still keep intact the splendor of wonder, the shudder aroused by anger, all our bitterness over the injustice. Together we shall come, sooner or later, to dwell forever in the moving center of beauty.

nly writing can endure, since voices and their sounds, inevitably, empty into silence and can be easily stilled, misinterpreted, omitted, forgotten. I write you now solely to forestall the shame that someday could lead me into shielding myself with silence. I know that although the outcome of this trial may condemn me, I am not really going to die. I want to assure you that I understand that I'm not risking physical extinction but, rather, that my loathing arises from the imminence of a moral death. Oh, think of it: remaining still alive and not feeling anything.

You dare to say that the neighbors have tried to protect me, and in that way you attempt to cover up this widespread surveillance. You said that they tried to protect me from myself and from my pernicious inclination toward rituals that these days everyone wishes to forget. But I knew that if I took part in the miserable practices, the vacuity, the slanted rumors fostered by the neighbors, I would have been practically dead, I would have changed into a subdued, lifeless figure. I can't accept the city's division into the visible or the invisible so as to contrive an impartiality that leads to the orgiastic arrogance of smugness.

Today my dread has retreated from me with the same effect as the sun's disappearing in these moments, eclipsed by the afternoon. My dread has retreated and I am calmly watching the fiery

figure of your son, who struggles to defend us from all the misery and vileness that keeps us locked up inside our house. I look at your son and convince myself that nothing could separate us since we were constructing our freedom when we distanced ourselves from your orders and mocked your cutting cruelty. I don't know who you are since you are everywhere, cloned in mandates, punishments, threats that pay homage to an uninhabitable world. I do not know who you are now, I don't think I've ever known you. Your mother isn't a living figure either, the neighbors are merely characters of war. Only your son and I are real. Only us.

The city confronts its own extremes: North and South have become enemies, East and West appear irreconcilable, consumed by a silent war, a mute, disproportionate battle, since the great emblem auguring victory is the desperate hunger that marks the borders. It's the hunger, I tell you, it is only the hunger. It's the hunger routed by gluttony. It's subjugation by greed. Oh, I no longer know who you are but, still, I am sure of the position you hold. As though you were a corrupt legislator, a policeman, an obsessed priest, a fanatical teacher. You mother has been the twin henchman of all these roles. Your mother and her cunning Western soul.

By now the surveillance has paralyzed us. I can't go out into the streets to look for food. There is an explicit restriction that prohibits our leaving the house since we've gone to numbering ourselves among

the banned citizens. But, how will the neighbors divert the course of the lethal waters? With what lies will they conceal the plague? Could the highlands and the fringes be eliminated? A sense of emotional death invades me. I understand that this feeling has been with me since I recognized the perverse plan that the neighbors hatched and that tormented me each time I awoke. And right now I see that I don't know what it means to exist without the burden and the memory this terrible sensation evokes. With the conviction of not belonging to any side now, I act guided solely by the necessity of protecting your son and banishing this feeling that has succeeded in leading me astray from my own life.

It's true that I'm capable only of dreaming some fringe words that are powerless to relieve me, so each one of my awakenings seems dangerously alike to me. But I depend on your son, an incredible, masculine child, who follows me everywhere with his outrageous laugh that frightens the neighbors. I know he understands how much we belong to each other, how we need each other; and the reason I depend on your son, this genuine, masculine child, is because I find the strength to resist and not participate in this hurtful pact.

Your son is now dragging himself across the floor, circling his vessels, and his thinking begins to speed up. From the circle he's fashioning it's possible to see that his scheme ends by closing in on him. At the center of his perfect circumnavigation there

begins to be described a world with its parts per-
fectly joined in order to form a whole. But now he's
breaking up the parts of his world and he gestures in
the semblance of a solitary dance. How wonderful.
Your son has just begun a strangely solitary dance. In
his face there's noticeable a regressive air that makes
the dance seem timeless.

I t's the end of the day, darkness now invades every corner and, with this darkness, the only images my mind can summon at present belong to the realm of night.

Oh, to me the darkness seems more impenetrable, more powerful, surpassed only by the occurrence of death. You know well that beyond, behind the dark, lies death. Darkness is thus the great abode of death, but stubborn death ends by reducing darkness to nothingness.

I mean, death and its dark, sacred ceremony. An infinite charnel house that erects, somewhere in space, a multitudinously inconceivable tomb. A millennial heaping of bones devoid of memory, now freed of the burden produced by desire, which rocks and consumes life. Bones awaiting their pulverization so as to make room, inside this unrealizable tomb, for the next bones and still others that have arrived defeated by all the darkness. But no one dies. I declare every final state a murderess. Death comes as assault, defeating darkness in order to pair warrior and victor in the midst of darkness. I want to assert that the only known death is weariness of life: its insult, its abuse.

Because I'm thinking now about that death, the one that leads life toward nothingness. Not about the one that sneaks crouching in the gloom, but about that darkness that falls, blotting out the center of light entirely.

I have lost the case. They have informed me of the cessation of my rights, the suspension of every

guarantee, the power, now conferred on you, over the crushed specter of my life.

But still: Who are you? Which neighbor do you pretend to be? Which house do you live in? From which official department have you issued your orders? Which of the West's latest commands are you obeying? I have lost the case and I'll be excluded from the banquet celebrating the imaginary triumph. I've been banished to the breach in the fringes, where they say plagues, the gratuitous infections caused by our intolerable ways, are bred. And I ask myself at this moment: Of all the fringes which falls to me? If the conclusive evidence in this trial was based on writing, writing is the reason for my condemnation. But I want to insist, and this is known, that I never wrote letters, I wrote only so as not to cover myself with shame.

The darkness has finally stabilized now. And my brain is beginning to clear. With my mind cleared, I overcome forever the sense of death to which they subject us. Neither you, and I don't know who you are, nor any one else can reach us now. We'll never give in to incarnating in our bodies the subjugation they promote. We have succeeded in defeating the neighbors' intentions, hiding ourselves from the wrongs this era could cause us.

The child and I are bringing to an end the ordering of vessels throughout the house. We've managed an arrangement that seems wonderful to us and that never before could have been conceived so

perfectly. We cross the game's frontiers unscathed, in order to advance along the path of a written survival—desperate and aesthetic.

Now that the sentence will not be carried out, nothing can be done to oppose our decisions. We'll leave the city to tear itself to pieces in the resistance it's putting up along its outer limits, in the greedy, open war between East and West. The house is now our only fringe and has been converted into a space impregnable to the West's neglect. They'll never be able to demolish the symmetry in which we've managed to concentrate our defenses. I've resolved, at last, the law's mathematical crossroads, put to me all this time by the child's game. A human game with labyrinthine edges that holds our only possible path of retreat. The child and I return exhausted, but satisfied, to the world order to which we dazzlingly give ourselves.

Oh, the child always was wiser than all my wisdom. During months, years, days, we have traveled from the game to the war's anguish. From the war's anguish to the solemnity of the word. We'll play forever and forever, and with the most precious solemnity we can muster: our skull, shoulder, hunger, femur, syllable, proud hip. Oh yes, and all our intense, strange, growing, angry skin. And there, in the last, the only room of the house, the stars now shine on the indefatigable rearrangement of the vessels. We shall reach them confidently. The child and I are already experiencing the silvered profundity of the vessel.

Oh, the child and I are overtaking it with this, our old, terrible, and mighty sun, between our teeth.

awn is breaking as I write. The luminosity falls over the wall against which I'm bracing my back. Today it dawns and dawns in this street, owing to the apathetic activity of nature which knows only how to repeat the monotony of its own grimaces. After daybreak, the day and nightfall and the enormous difficulty of nightfall. The child goes on enthralled by the light's movement. He laughs amid the light. Will I find another wall against which I can brace my back? It's necessary that I try. But the child, who's beside himself with the light, doesn't seem to want to budge.

(I can write now only at the precise moment when day is breaking.)

The child remains self-absorbed. I'll find a way to shake him up. It's quite a while now that we've been wandering about, enacting an impoverished nomadism. And the hunger. The hunger we drag everywhere during this long, incalculable time. Someone questioned me brusquely when night had already fallen. And I, timid, responded with great caution:

"Yes, this child's mine. Yes, yes, my name is Margarita, I don't even know how old I am."

ЯЯЯ8, the night and Mama fuse in me. Mama and I are wandering tonight. Tonight, the days and the nights. Always together, we endlessly wander the street. The street. People on the street scarcely conceal their uneasiness. Their uneasiness is everywhere. ſſſſſſ, the uneasiness spreads. ſſſſſſſ. Somebody wanted to destroy Mama. I know. To destroy and silence Mama. The people who keep watch on the streets hate the presence of Mama. Of Mama. ЯЯЯ8, the hatreds flog me. But Mama doesn't write now because she seeks to fuse with the night. The night. Mama's fear is concealed in the leg that drags me along. I climb up her leg and cling to her hip because the darkness and the people who keep their eye on us threaten me. Threaten me. It seems that Mama's nighttime writing might never have come to an end. End. But Mama gives her word now that it alone protects us and that we are saved by the darkness of her writing. Of her writing. Mama still holds on to some of her thoughts. The thoughts she holds on to are mine. Are mine. I'm identical to Mama's fingernail, her finger, her subjugated hand. I am bent over by powerlessness in the middle of the page she could scarcely write. Mama didn't write my thoughts. Mama never knew for whom she wrote her words. For whom she wrote her angry, useless words. Oh, Mama and her heap of mistakes. Mistakes. It's her fault we wander night and day, and her leg. Now somebody hits Mama's writing. ЯЯЯ8, Mama cringes and shields her head. Her head. Certain people batter

Mama in her thoughts. WAK WAK WAK WAK. And the blow a very hard one. We fall. Mama and I flail against the ground. I search for Mama's fallen face, she's getting sick. Sick. Her writing sickens Mama. The writing she can't bring to an end. And the hunger. We're hungry but they pursue us and the night punishes us. AARS, the hunger. I want to lose myself with Mama in the most extraordinary moments of the night. Of the night. Mama's leg, her hip are weary. Weary. My head of a DUM-DUM DUM-MY wants to flee the night and travel with Mama's hip into the dawn. But Mama's failure turned us into nocturnal creatures, scorned, scared. Oh, yes, fugitive, hated, nocturnal, and scorned. SHHHHHT. AARS, the hatred. Mama is on the verge of crying but I don't let her. SHHHHHT. Now I'm close to controlling this story, of dominating it with my head of a DUM-DUM DUM-MY. Of a DUM-DUM DUM-MY. Mama and I will end up fusing. Fusing. Thanks to me, Mama's dark writing hasn't failed entirely, it's just that the night leaves it diluted. I want to guide Mama's distorted hand and bring it into the center of my thoughts. Of my thoughts. I have to lead Mama through this darkness which I know. To take, take Mama far from the irritation and the mockery and the indifference provoked by her writing. Her writing. Mama doesn't speak now and she rocks herself at a corner. She's rocking herself at a corner, at the corner of this sole street that makes us exist. She rocks and lulls herself. I hide in her leg. SHHHHHT. Mama is tired and wants to sleep. To sleep.

All Mama thinks about is sleeping, now that I'm close to snatching from her the page that made her impressive. Impressive. Tonight we'll reach the bonfires. The bonfires. *CRRRR*, they crackle. We'll reach the men tending the fires, who will receive Mama distrustfully. They'll receive her indifferently, distrustfully. Mama will drag me along without bothering about the state of my head of a *DUM-DUM DUM-MY*. But if I don't hold up her hand, we'll extinguish ourselves along with the fire. We're tired. Tired. Mama's insatiable and incomprehensible hunger tires me. I want Mama to get beyond hatred and indifference. Hatred and indifference to her writing. We're heading toward the bonfires, with me clutching Mama's hip which is cramped and crushed by my weight. My weight. Oh, those words she couldn't clarify. I don't speak. Don't speak. The streets lengthen in the night, turn ominous. Ominous. Mama wants to collapse in the streets and abandon me. But still we continue on this dark and secret journey in order to reach where the *CRRRRR*, crackling bonfires light up the fringes. *AAAIE*, Mama has lost a great part of her thoughts on this dreadful and vigilant trek. She's lost her strength as well as her thoughts. Thoughts. I clutch Mama's hip with the little strength I have and I lick and warm her hand that's holding me up. Holding me up. We're hungry. Hungry. Mama's hunger isn't satisfied by food. Mama took pleasure only in her writing. That writing she no longer can finish. I sate myself on Mama's hand. My head of a *DUM-DUM*

DUM-MY always foresaw that Mama was going to be defeated by the aridity of the page. Of the page. I wanted to gnaw, claw Mama to get her away from her useless writing. I don't speak. Don't speak. We're losing the fervor. Mama's hip is cold, and frightened. Frightened. My mouth that doesn't speak freezes. They keep their eye on us. Some follow us through the shadows with a bold, harsh eye. They follow us with a bold, harsh laugh. Inside there they concentrate their gaze. And farther inside we are kept under eye by other words and the people who know how close we're coming to the fall. The fall. Now Mama and I have only the flesh of our bodies and the grievous remains of thoughts. Of thoughts. Mama slowly moves her leg so that I WAK WAK WAK WAK fall and bump myself and remain in a heap forever on the only corner. But if I fall, Mama will lose her last thought. AAA18, Mama halts very dark against the impassable, frozen wall. BRRRR, I shiver. BRRRR, we shiver. The terrible, arrogant, and treacherous eye blinks in delight now that it sees how fast we're growing faint. Growing faint. With what few teeth I have I gnaw Mama's hip and SCRRRR, scrape her leg. I gnaw her and scrape her since now I must lead Mama toward the fires so we're not annihilated by the cold. The cold. Night closes in and hides the star and sky that are Mama's. Mama's. A certain watchful eye follows us with all kinds of looks. These dangerous looks keep watch on us from the center, and Mama's writing needs to darken more, more in order to defend us.

Defend us. Mama has finished. Just now she ends by falling. I must take Mama's writing and place it at the center of my thought. Because it's I who must guide Mama's hand. Her hand falls against the floor, crumples to the ground at this sole corner at which we end up finding each other. If Mama doesn't steady her hand I'll hit her with the little strength I have. Now Mama doesn't speak. Doesn't speak. Mama is the DUM-DUM DUM-MY of the city streets. City streets. A notorious and merciless taunt hounds us and sates itself along the avenues. AARGE, the hunger. I'll drag the DUM-DUM DUM-MY to the bonfires and hand her over to the men tending the fire. The fire. AARGE, I'm dragging her. I'm dragging her. Tonight and night and day. Mama's head WAK WAK WAK WAK strikes against the ground. She's hungry. I know. Hunger. I must look for a bit of food to feed her. Feed her. Somewhere on the ground I find a bit of food and I dodge the dreadful, unfeeling gaze that pushes us to the fall into hunger. Hunger. Mama opens her mouth and I introduce the food and place it on her tongue. On her tongue. Mama, terrified, bites my finger and faints. Faints. If Mama doesn't revive I'll abandon her on this corner, on the only corner that protects us and makes us exist. But Mama pulls herself together and **baaam, baaam**, she laughs. To me her laugh is annoying. Annoying. I ought to lead Mama to the fires that will allow us to get through this night. This night. Oh, Mama refuses and becomes stubborn curling up against the icy wall. Icy wall. BRRRR. It's

dark and I'm afraid of losing her. Finally I stand up and hold Mama's hand fast to my leg. To my leg. I must drag Mama to the fires, but she curls up and pokes her fingers in the dirt. In the dirt. Mama wants to bury herself in the dirt. I take her finger and put it in her mouth that doesn't speak. Doesn't speak. Mama, with her finger, smears my leg with the drool and **baaam, baaam**, she laughs. She laughs and beats her head **wak wak wak wak** against the ground. My heart **tom-tom tom-tom** beats angrily and wearily. Wearily. **tom-tom tom-tom**, cutting through the darkness dragging the **dum-dum dum-my** of the city streets and her interminable drool. Mama is intensely, unscrupulously resentful because her former writing exhausted her thought. I know. That's why she drools all the time and **baaam, baaam**, she laughs. Mama is now the **dum-dum dum-my** of the city streets. City streets. In her head of a **dum-dum dum-my** the hunger encircling the streets lingers on. Oh, they are keeping an eye on us. Keeping an eye on us are certain vengeful eyes no less stern than those that worship the fall. Mama's irreversible fall. We are down below, down here where the **dum-dum dum-my** of the city streets **wak wak wak wak** has ruined her back to the point of destroying her writing. Her writing now is as much mine as the unreachable star is another's. The drooling head of the **dum-dum dum-my** of the city streets still howls for the sky where she's awaited by a star. A star. I must shift her from my hip to my leg until the fires that **cr-rrr**, crackle their brilliance. If we reach the ut-

most flames we'll demolish the spying eyes that want the dirt at this one corner to entomb my writing. My writing. Now I write. I write with Mama clutching my side, drooling without letup and **baaam, baaam**, laughing. Laughing. Mama doesn't want me to write and clings to my leg in order to shred my words. Words. Mama fears the indifference of my back. Of my back. She makes an unhealthy sound ΜΜΜΜΗΗΗ with her mouth. Now we're going to the fires. We're going to the fires cutting through the night's rigidity in order to end this story which already seems interminable to me. Sterile and interminable. Mama gnaws at me and **SCRRR**, scratches my leg because she's demanding from me the star and that sky she's spent so many years waiting for. Waiting for. A star that's bluer, bluer than the cold of our skin. Mama is the DUM-DUM DUM-MY of the city streets. If I don't hold her up, a certain incredible eye that keeps us under surveillance will demolish us forever. Forever. Oh, I've worked out a street down which to carry Mama, to go down with the DUM-DUM DUM-MY of the city streets in order to reach the flames that will make us survive one night. Now I control this story. I carry Mama along my own path. **ΛΛΛʒɛ**, but a terrible and powerful word tries to erase my thought. My thought. Mama scarcely has thoughts now. She has only drool and her laugh. Her drool dangles to the ground and mixes with the dirt. **baaam, baaam**, she laughs and shivers. Mama's turning blue and I even bluer, bluer, wearing myself out trying to get

her out of this night. Mama and I can only love each other on this unending journey covered by her drool that stains all the space. The space. Way over there they say the fires *CRRRR*, crackle and they also say that the shapes of the flames reduce hunger. We're hungry and we're cold and the writing evaporates and becomes even more useless. Useless and distant. I drag useless and distant writing over a barren surface. I drag it. A certain vigilant, assured eye laughs at my meager surface. *AAAJ6*, my leg buckles and is injured. Mama clings fiercely to my leg as she formerly did to her passion for the page. The drooling *DUM-DUM DUM-MY* of the city streets ruined her writing and now I must correct it. The drooling *DUM-DUM DUM-MY* of the city streets hardly knew what she was writing and never understood to whom she was writing. **baaam, baaam**, Mama laughs and coils on my hip. I'm carrying Mama to the fires in the midst of such cold and darkness that I don't know how we're able to bear it. And at this moment, Mama arches. Arches. I hit Mama in her head of a *DUM-DUM DUM-MY* so she'll settle down. Settle down. Mama opens her mouth to say *AAAJ6*, but **baaam, baaam**, she laughs and gnaws my leg with what few teeth she has. Mama wants me to write her thoughts. Her thoughts. But Mama has destroyed her thoughts on this too *DUM-DUM DUM-MY* journey, just like her *DUM-DUM DUM-MY* head. **aaggg**, Mama vomits over my leg from the cold. From the cold. The vomit arouses her hunger. Hunger. I extract the last, the last, the last drops of milk from Mama's breast and

put my mouth on her mouth. On her mouth. Mama
tastes her milk in her mouth and wants to spit it out, but
I shut her mouth with all the strength that I have. That I
have. I force her to swallow her milk. Her milk. Ah,
Mama insists on spitting out her last, last, last drop of
milk but I don't let her, and I hit her on her head of a
DUM-DUM DUM-MU. Mama MMMMHHH, mumbles angrily
and rolls her head around in the dirt. We will reach,
I will drag her to the flames in order to forget the
cold piercing me more viciously than Mama's few
teeth in my leg. Mama doesn't speak now. Doesn't
speak. TOM-TOM TOM-TOM, her heart beats into my
side. Into my side. Mama wants me to write the few
thoughts she has. I must drag Mama to where the
men tending the fire are taking shelter and once and
for all leave this one corner that barely makes us ex-
ist. Exist. AAAT6, my eyes still don't catch sight of the
flames. The flames. Other expectant eyes look for-
ward to my fall. Mama has already fallen. She can't
let go of my leg. Of my leg. Mama clings to my leg
with the little strength she has and MMMMHHH
mumbles hunger. Mama is always hungry now and
thinks only about eating. I can't find even a tiny bit
of food for Mama. Mama drools more and baaam,
baaam, laughs. Laughs. I stick a fold of her skirt
into her mouth so she'll be quiet. Be quiet. Mama
aaggg, chokes and spits out the cloth. I'm weary.
So weary I stop. I set Mama down braced against the
wall and I sit down beside her. Beside her. But Mama
rolls on the ground and takes up some dirt and puts

it in her mouth. In her mouth. Angrily I take the dirt out of her mouth and Mama gets annoyed. Gets annoyed. We are the DUM-DUM DUM-MDS of the city during this night that's becoming infinite. An infinite night and not a single star. Star. We have to find a star and some fire in order to salvage the little existence we have left. Have left. I look for a star and only bump into the darkness. The darkness. Together Mama and I drool hunger. A certain unyielding stare laughs about the fall. Fall. Mama and I won't know how to get up off the ground. Her leg and mine get tangled up, BRRRR, we shiver together from the cold. TOM-TOM TOM-TOM, my heart, her heart. I seek Mama's breast to warm myself but it's as frozen as her leg. Her leg. Mama no longer has any milk left in her breast, not even a single drop of milk is left in her breast and MMMMHHH we mumble a sound that causes the first tear to roll. Tear to roll. The tear is tasty, salty, warm as toast. But we still drag on searching for a little heat. Heat. baaam, baaam, we laugh together. DUM-DUM DUM-MY, Mama's heart and my heart now keep the same beats. Beats. Some ever watchful and wide-ranging eye gets ready for an overwhelming failure. AAATS, the stabbing cold, BRR-RR, cuts through us. Mama hits me in my head of a DUM-DUM DUM-MY to make me show her the star. The star. And I hit her in her head of a DUM-DUM DUM-MY. She bites me with what few teeth she has because she wants me to carry her to the sky she has longed for. Longed for. We fall to the ground drooling, drooling with

the little saliva that slides from the tongue to the mouth that's still open. Open. Our saliva mixes and fuses. Fuses. But we must drag ourselves to the bonfires and Mama grabs at the few hairs I have in order to support herself. Support herself. She wants to pull out my hair and completely drain my drool from the dire necessity of hunger. Hunger. We are on the verge of losing the last, the last, the last thought. There, in the darkness of these fringes, appear the fires. The fires. With hard work Mama and I drag ourselves, entangling our legs and the drool and the ʙᴀᴀᴀᴍ, ʙᴀᴀᴀᴍ, laugh we have left. Here is the sky we've wished for so long now and we greet it with a renewed laugh that ʙᴀᴀᴀᴍ, ʙᴀᴀᴀᴍ, pierces the night. ʎʎʎᴊꞬ, we draw near the starry brightness in order to remain in this last, last, last refuge. The crushing, sarcastic surveillance can no longer reach us. Reach us. Mama and I ecstatically draw close together while I forget my hunger for her body, my desire to fuse my flesh with hers. With hers. We surrender ourselves to this starry night and from the ground we lift up our faces. We lift up our faces to the last, last, last sky which is in flames, and we remain fixed, hypnotized, motionless, like dogs *ℋOOOW, ℋOOOW, ℋOOOW,* howling at the moon

Diamela Eltit is a Chilean writer and artist. She began producing works during the Pinochet dictatorship, staging actions as part of the artist collective CADA (Colectivo Acciones de Arte—with Raúl Zurita, Fernando Balcells, Lotty Rosenfeld, and Juan Castillo—active between 1979 and 1985) and publishing her first novels, *Lumpérica* (*E. Luminata*, 1983) and *El Cuarto Mundo* (*The Fourth World*, 1988). She has received many literary prizes, including Chile's National Prize for Literature in 2018, the Carlos Fuentes International Prize in 2020, and the FIL Literary Prize in 2021. She is Distinguished Global Professor of Creative Writing in Spanish at New York University; was a professor, from 1986 to 2019, at the Metropolitan University of Technology in Santiago de Chile; served as the Simón Bolívar Chair at Cambridge University; and has taught at University of California, Berkeley, Columbia University, Stanford University, and Washington University, among other institutions. In 2013, Princeton University acquired her archive.

Helen Lane (1917–2004) was a translator who worked primarily with French, Italian, Portuguese, and Spanish literature. From 1960 to 1970 she was a foreign editor at Grove Press. She translated many authors, including Mario Vargas Llosa, Octavio Paz, Marguerite Duras, Nélida Piñon, Curzio Malaparte, Jorge Amado, and Maria Montessori.

Ronald Christ is the cofounder of Lumen Books and *SITE* magazine. He is Professor Emeritus of English at Rutgers University and has served as the president of PEN New Mexico. He has written and published original works and works in translation extensively, and his translation of Diamela Eltit's *E. Luminata* was awarded the Eugene M. Kayden National Translation Award in 1998.

Diamela Eltit
Custody of the Eyes

Translated by Helen Lane & Ronald Christ

Published by Sternberg Press

Graphic Design: Roxanne Maillet
Cover Lettering: Marie-Mam Sai Bellier
Proofreading: Max Bach
Printer: Tallinn Book Printers

ISBN 978-3-95679-606-7

Originally published in Spanish as *Los Vigilantes*
© 1994 Editorial Sudamericana Chilena
Originally published in English © 2005 Lumen, Inc.
Translation © 2005 Ronald Christ

Distributed by The MIT Press, Art Data,
and Les presses du réel

Sternberg Press
71–75 Shelton Street
London WC2H 9JQ
www.sternberg-press.com

MONTANA

Edited by Leah Whitman-Salkin

Montana is a propositional series exploring the adjacencies of the literary and the visual, the poetic and the political. Deeply invested in the production of a radical present and future, the books of Montana form an ecology of thought that is connected in spirit, practice, and language, yet distinct and diverse, spanning geographies and time.

Diamela Eltit
Custody of the Eyes

Valerie Solanas
Up Your Ass